IMAGES
of America

FARMING IN TORRANCE
AND THE SOUTH BAY

ON THE COVER: An entrepreneurial couple, believed to be H. G. and Grace Conkling, are seen marketing the healing properties of their goat milk, inviting customers to come on down to their ranch at 21100 South Normandie Avenue with their clever (although misspelled) slogan: "Maybe It's Goat Milk You Need For That Extra Umph," in this early-1940s photograph. (Courtesy Torrance Historical Society and Museum.)

IMAGES
of America

FARMING IN TORRANCE
AND THE SOUTH BAY

Judith Gerber

ARCADIA
PUBLISHING

Copyright © 2008 by Judith Gerber
ISBN 978-0-7385-5930-8

Published by Arcadia Publishing
Charleston SC, Chicago IL, Portsmouth NH, San Francisco CA

Printed in the United States of America

Library of Congress Catalog Card Number: 2008921573

For all general information contact Arcadia Publishing at:
Telephone 843-853-2070
Fax 843-853-0044
E-mail sales@arcadiapublishing.com
For customer service and orders:
Toll-Free 1-888-313-2665

Visit us on the Internet at www.arcadiapublishing.com

To my husband, Daniel Thomas Hylands: your support and encouragement are more valued than mere words can say. Thanks for always jumping in to help and taking on my passions as if they were your passions. I literally could not have done this book without your help.

CONTENTS

ACKNOWLEDGMENTS

This book would not be as photographically diverse and interesting without the assistance from the wonderful people in our community.

First and foremost, I want to thank Janet Payne and Debbie Hayes of the Torrance Historical Society and Museum. Their help and encouragement are greatly appreciated, and this book would not be possible without their assistance. Janet spent her own time looking for items and information, and Debbie constantly gave me contacts and encouragement.

I also owe a great deal to James Osborne, who not only encouraged me to do the book in the first place but showed me how to scan photographs, let me scan his family photographs, proofed parts of the book, and basically acted as my unpaid consultant.

I want to thank the following for their contributions: Ron Allen, Inspector III, Los Angeles County Agricultural Commissioner/Weights and Measures; Pamela Amodeo-Morris, chief deputy city clerk, Gardena City Clerk's Office; Cynthia Becht, head, Archives and Special Collections, Loyola Marymount University; Marjeanne Blinn, Adult Services librarian, Palos Verdes Library District Local History Collection; Carolyn Cole, curator, photographic collection, Los Angeles Public Library; Community Services Department, City of Torrance; Kurt E. Floren, Los Angeles County Agricultural Commissioner, director of Weights and Measures; Michael George, reference librarian, Torrance Public Library; Ethel Pattison, LAX Flight Path Learning Center and Museum; Sam Gnerre, librarian, *Daily Breeze*; Tom Philo, archivist/cataloger, Archives and Special Collections, California State University Dominguez Hills; Dace Taube, Regional History Collection librarian, Special Collections, USC Libraries; Torrance Historical Society and Museum; Dana Vinke, Reference Services supervisor, Torrance Public Library; Cindy Werner, Inspector III/archivist, Los Angeles County Agricultural Commissioner/Weights and Measures; Ruth Wallach, head librarian, Architecture and Fine Arts Library, USC; and Greg Williams, director, Archives and Special Collections, California State University Dominguez Hills.

Lastly, I want to express my sincere gratitude to the individuals who contributed their photographs, stories, and time to ensure that the stories of our family farmers were told completely and accurately: the Andrade family; Paul R. Comon; Doug Hatano; Richard Hudson; Dave and Sue Ihori; Tom T. Ishibashi; Leroy Jackson, city manager, City of Torrance; Bill and Joelene Mertz; Jack Omatsu; Verne Palmer; Roy Pursche; the Vaccaro family; Joe and Dahlia Verburg; Jim Weiss; and Mary Lou Weiss, market manager, Torrance Certified Farmers' Market.

INTRODUCTION

Farming, ranching, and all agricultural-related activities have played a major role in the economic, cultural, and political history of Torrance and the South Bay. Traces of its influence can still be found today. While agricultural activities date back to the Gabrielino/Tongva Indians who populated the region, ranching—especially cattle ranching—became a huge component of the landscape when the Spanish and Mexican ranchos flourished in California in the late 1700s through the mid-1800s.

Even before California became a state, there were decades-long disputes between several families claiming rights to the same lands, including the Dominguez and Sepulveda families over Rancho San Pedro, which included parts of present-day Torrance, Carson, Lomita, Gardena, and the Palos Verdes Peninsula. The Avila and Machado families fought over Rancho Sausal Redondo, which included present-day Redondo Beach, Hermosa Beach, Manhattan Beach, El Segundo, Inglewood, and Lawndale.

After the Mexican-American War ended and the United States took possession of California in 1848, the United States signed the Treaty of Guadalupe Hidalgo, saying it would honor the legitimate land claims of Mexican citizens. However, shortly after the treaty was signed, gold was discovered in California, resulting in a major influx of Anglo and European immigrants.

While this influx was more prevalent in Northern California, the Los Angeles area also saw a huge population increase and, with it, increased cultural and political changes. One of the most significant of these was the passage of the California Land Settlement Act of 1851. Under the act, the U.S. government required owners to file land patents to prove the validity of their land titles.

Although the filing of land claims inevitably led to a final resolution of land conflicts, it took many years and dozens of lawsuits. Under the U.S. land patent, Antonio Ignacio Avila kept his claim to Rancho Sausal. It also declared that the Dominguez family's Rancho San Pedro now encompassed 25,000 acres, far fewer than the 75,000 acres included in the original land grant. The Sepulveda family kept the 31,000 acres on the Palos Verdes Peninsula that it had been awarded by Gov. Pio Pico in 1846.

During these years of land disputes and political turmoil in California, many of the original family members had died and many went into huge debt fighting lawsuits. In the late 1800s, there was also a major depression in the cattle industry, followed by a prolonged drought. While small portions of rancho land had been sold off before, these factors led to larger portions of rancho property being disposed.

But agriculture's predominance did not end as the rancho land changed hands. On the contrary, those who purchased the land were ranchers or farmers themselves, and many came to California specifically to pursue agricultural activities and ultimately became the largest landholders in the region.

These included Benjamin Stone Weston, who bought 3,000 acres in present-day Torrance. Weston's land ran from Madison Street to the Lomita city limits and from Sepulveda Boulevard

to the Palos Verdes foothills. All of the land that today makes up the Torrance Airport was at one time part of the Weston Ranch. At 17.5¢ per acre, the land cost him $525. Weston had purchased his land in 1847 from the Sepulveda family on the original Rancho San Pedro while the Dominguez family was still fighting to get it back.

When he first started ranching, Weston raised cattle and horses in the foothill section and crops in the lower flat land. These included sugar beets, alfalfa, lima beans, hay, oats, and barley. In the 1890s, Benjamin Weston hired his nephew Orin Stocker Weston to manage the Weston Ranch while he moved to Wilmington to operate a hardware store. The Westons began to lease out large portions of the ranch at the dawn of the 20th century.

There were other large ranches in the area near Weston's during the same time. Most of them also raised hay, barley, and lima beans. A lack of irrigation forced Torrance farmers to practice "dry farming." This meant they had to rely on rainfall and haul pails of water to their crops by hand if this was insufficient.

These included the Emil Kettler Ranch, with over 200 acres raising corn, hay, grain, and lima beans; the Joe and Tom Venable Ranch centered at the intersection of Hawthorne Boulevard and Pacific Coast Highway; the Ellinwood Estate of Dr. Charles Ellinwood, which also raised cattle, grains, and beans at the site of present-day South High School; the Charles Quandt Ranch, which raised dairy cattle and owned the Quandt Water Works; and the Narbonne Ranch.

Nathaniel Narbonne bought 3,000 adjoining acres bordering Weston's ranch, including most of what is Lomita today and parts of Harbor City. Together their land went from the north slope of the Palos Verdes Peninsula almost to Sepulveda Boulevard between Western Avenue and Hawthorne Boulevard.

In 1852, Narbonne and Weston entered into a partnership raising sheep both on their local ranches and on Catalina Island, where there was more foliage and no inhabitants. In addition to sheep, they also grew lima beans, grain, and hay.

When Narbonne was tragically killed in a fire in 1881, his widow, Margaret, began selling off parts of his land. By 1917, the long drought of the 1870s led to the failure of the area's bean crop and resulted in the sale of the rest of Narbonne's ranch land.

During this same time, farming grew in other areas of the South Bay. On the Palos Verdes Peninsula, Harry Phillips became the ranch manager for George Bixby, who, in 1894, had taken over his father's, Jotham Bixby, land interest. Phillips built his first house on land southeast of present-day Rolling Hills City Hall and raised over 2,000 cattle, horses, and sheep and grew lima beans and barley for hay and grain.

Another large portion of South Bay rancho land was sold after Antonio Ignacio Avila died in 1858. Some of Sausal Redondo was sold to Scotsman Sir Robert Burnett, who leased and ultimately sold a large portion to Canadian Daniel Freeman. Freeman built up a large agricultural operation, first focusing on raising sheep and planting several thousand citrus, almond, olive, and eucalyptus trees.

After the drought of the mid-1870s, he switched his focus to growing barley and other grains for sheep, horse, and cattle grazing. He shipped millions of bushels of barley from his wharf at Playa del Rey. Freeman's success at large-scale dry farming led him to undertake a number of other business ventures, including the sale of part of his 25,000-acre ranch to create a town he called Inglewood.

Los Angeles County agriculture statistics for the early 20th century, from 1900 onward, indicate that agriculture was the primary industry of Los Angeles County with the top activities being dairy farming, fruit growing, and truck farming. Agriculture was also the dominant industry throughout the South Bay, and the predominant crops were hay, barley, lima beans, strawberries, celery, and flowers.

In the early 1900s, poultry ranches became another important agricultural commodity in most South Bay communities, especially Lomita, Lawndale, and Inglewood, all of which advertised their communities as great places for poultry colonies. Inglewood first advertised its poultry colony in 1905. Lomita saw commercial poultry ranches spring up for raising fryers and eggs to

sell at markets and roadside stands. Lawndale advertised itself as Lawndale Acres to draw people in. The agriculture commissioner's office indicates that Los Angeles County was the nation's top farm county from 1909 to 1950, when the county, including the South Bay, saw a boom in post–World War II residential development that brought dramatic change and the replacement of farm acreage with suburbs.

This was particularly true in Torrance. Despite being founded in 1912 by Jared Sydney Torrance as an "industrial" city and incorporating in 1921, family farming played an important role in Torrance's economy throughout its early years. Family farmers remained an important part of the city's economy as it transitioned from an agricultural center to a thriving suburban community in the late 1950s.

Throughout those years, the lima beans, barley, hay, and celery all remained as staples in Torrance, as did a wide variety of produce, such as strawberries, squash, asparagus, cucumbers, carrots, and sweet corn.

There were also a number of flower farmers growing a wide variety, including carnations, chrysanthemums, sweet Williams, calendula, and delphiniums. In fact, the site of the present Torrance Civic Center was home to fields of the hybrid delphinium, the official city flower, grown by T. Muto from 1928 through 1941.

Additional agricultural commodities came and went as well. Throughout the 1920s, dairies were established throughout the city, and by the early 1960s, there were approximately one dozen left. In the mid-1960s, city ordinances outlawed their existence, and they were all forced out by 1965.

The city was also home to some unusual and interesting commodities, including mushrooms grown at the J. J. Millard Mushroom Ranch. It was at one time located on Sepulveda Boulevard near the present-day Sears parking lot. At one point, Millard supplied the Los Angeles area with about 25 percent of its mushrooms.

Torrance was also home to a chinchilla farm, pig farms, turkey ranches, horse stables, goat milk operations, apiaries (beekeepers), a bird farm, figs, avocados, and even an orchid and gardenia farm that, in 1936, produced five million gardenias a year.

This diversity of farming commodities was true of other agricultural-based cities as well, and each community became known for one or two particular commodities. Redondo Beach was famous for its fields of carnations and other flowers, such as stock, asters, marigolds, and snapdragons. From the 1920s through the 1950s, flower stalls lined Pacific Coast Highway. Throughout the 1950s, flower fields were planted along Artesia Boulevard, Rindge Lane, 190th Street, Hawthorne Boulevard, and on Prospect Boulevard from the Hermosa Beach border to Pacific Coast Highway.

Early in the 20th century, Gardena's biggest commodity was berries, especially strawberries. It was known as the "Berry Capital of Southern California" and "Berryland." Its Strawberry Day Festival and parade every May drew thousands of people. After World War I, the berry industry began to die off when land was used first for other crops and then later for development.

In the 1930s, Lomita began to be referred to as the "Celery Capital of the World," but this title is often disputed since the area around Culver City and Venice had an even higher production of celery. However, in the first half of the 20th century, Lomita's local economy did rely heavily on truck farming, particularly of celery and strawberries.

The Palos Verdes Peninsula became known for its dry farming industry, comprised mostly of Japanese American farmers. There were dozens of Japanese farmers on leased land from White's Point to Palos Verdes Estates growing produce such as beans, peas, cucumbers, tomatoes, corn, melons, and potatoes. To compete with larger growers, they formed a cooperative, the San Pedro Vegetable Marketing Cooperative.

Japanese immigrants were also a key part of farming activities in other areas of the South Bay during the years before World War II. In Torrance, many Japanese farmers leased land from the Westons and the Ellinwood Estate in Walteria and in other parts of the city, including the Meadow Park area, before it was annexed to the city in 1927. After being interned in World War II, most Japanese farmers never returned, and it is believed that is part of the reason farming lost its economic importance in the region.

The housing boon of the early 1950s forever changed the face of agriculture in Torrance and the South Bay. In 1950, there were approximately 13,400 acres of field crops, including hay, grain, and beans, in the South Bay area, and by 1976, there were 670 acres left.

The celery industry that had once been so dominant in the region—in 1950 the county produced $5.5 million worth of celery on 2,300 acres, most of it in the Centinela–South Bay area—did not fare well either. By 1976, celery production was at zero.

As late as 1963, the Torrance agricultural inspection district had nearly 2,200 acres devoted to agricultural commodities that included beans, cabbage, celery, corn, lettuce, squash, strawberries, lima beans, dry beans, and barley.

By the mid-1980s, as agriculture all but faded away, there was still some acreage devoted to farming. In 1984, the South Bay produced approximately $307,000 worth of crops, including nursery stock. The largest crops were lima beans and barley, and there were also still Christmas tree farms, snap beans, and other miscellaneous vegetables being grown at the time.

Today there is only one traditional family farm left in Torrance: Tom T. Ishibashi's Farm located at the Torrance Airport. It is the only direct connection left to Torrance's farm history, but it is not the only agricultural activity in the city or the region.

Urban agriculture is the newest form of farming, and its prevalence in the South Bay often goes unnoticed. But it still contributes significantly to the local economy. It includes nearly one dozen South Bay farmers' markets. The county's first farmers' market (and the first farmers' market in the state) opened in Gardena in 1979 and is still in operation today. The third largest farmers' market in Los Angeles County is the Torrance Certified Farmers' Market.

Today, as in the rest of Los Angeles County, nursery stock, including ornamental trees and shrubs and bedding plants, remains the top agricultural commodity in the South Bay. According to the Los Angeles County Crop and Livestock Report, in 2006, Los Angeles nursery products contributed over $200 million to our economy.

While once abundant open space is now gone, "city farmers" are working on utility rights-of-way that do not allow permanent structures on them. Nearly 2,000 acres are being used for agriculture or horticulture under Southern California Edison's power lines in Southern California. Hundreds of others are leasing plots at community gardens in Torrance and other communities to grow their own produce.

The contributions of the area's earliest farmers can still be seen as one drives around our communities. There are streets, schools, hospitals, and parks named for them: Purche Avenue, Weston Road, Vaccaro Court, Daniel Freeman Hospital, Narbonne High School, and Bodger County Park, to name a few. Even Los Angeles International Airport, also known as LAX, would not exist if it weren't for the existence of the Andrew Bennett Rancho, part of which was leased to the City of Los Angeles in 1927 to create Mines Field, now known as LAX.

One

AGRICULTURAL HERITAGE AND BEGINNINGS
1880s THROUGH 1920

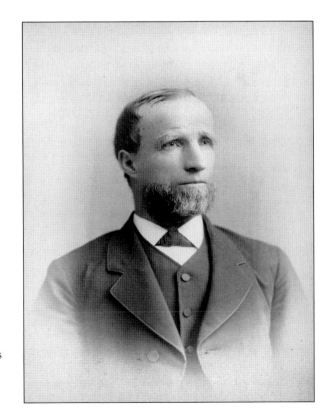

This is an 1884 portrait of Benjamin Stone Weston, who purchased 3,000 acres of the original Rancho San Pedro from the Sepulveda family for $525 in 1847. Weston was the biggest landowner in the area that is now known as south Torrance. The Weston Ranch ran from Madison Street to the Lomita city line and from Sepulveda Boulevard to the Palos Verdes foothills and was adjoining the Phillips Ranch/Palos Verdes Ranch on the Palos Verdes Peninsula. (Courtesy Torrance Historical Society and Museum.)

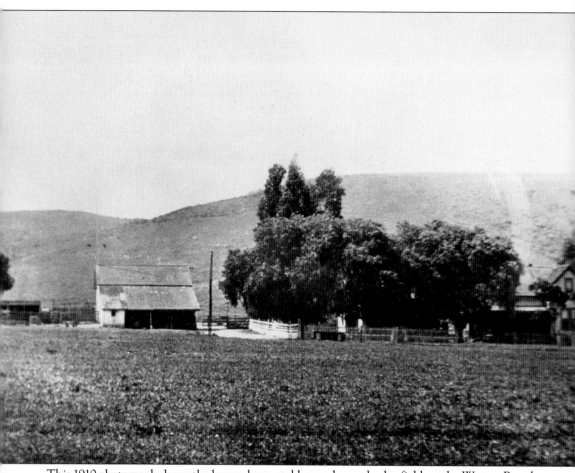

This 1910 photograph shows the house, barn, stables, and some barley fields at the Weston Ranch. The Weston Ranch was the largest ranch in Torrance and included all of what is now Torrance Airport. It included a creamery, water well, barns, and a foreman's house. Weston raised cattle and horses on the hillsides and crops on the low flat land, needing little or no irrigation to grow crops such as hay, beans, alfalfa, oats, and barley. (Courtesy Paul R. Comon Collection.)

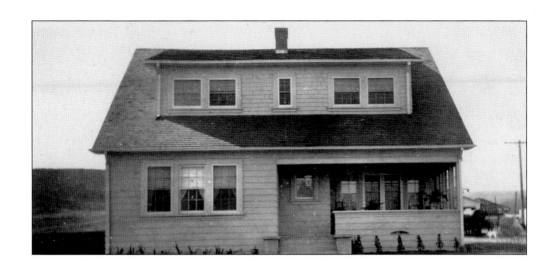

The Weston Ranch house pictured here is one of three houses that were built on the ranch. The original ranch house built for Orin Weston and his wife, Sarah, did not suit Sarah, so they had a second home built. The ranch foreman then used the first house. And when Orin and Sarah's son, Benjamin Price Weston, married Dorothy Ross, they built a third house for the young couple. The Weston Ranch house was located about one-half mile south of present-day Pacific Coast Highway. (Both courtesy Torrance Historical Society and Museum.)

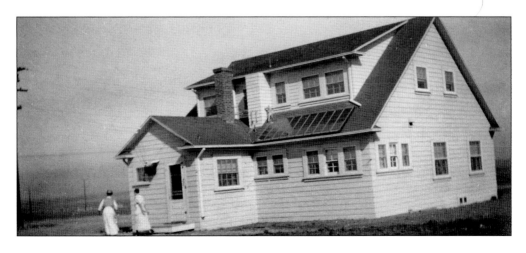

Orin Stocker Weston, Benjamin Stone Weston's nephew, is pictured standing between the barn and the house at Weston Ranch in Torrance. He came out from Georgetown, Massachusetts, in the late 1880s, when he was hired to manage his uncle's ranch. Benjamin Weston did not live on the ranch but in Wilmington, where he ran a hardware store. (Courtesy Torrance Historical Society and Museum.)

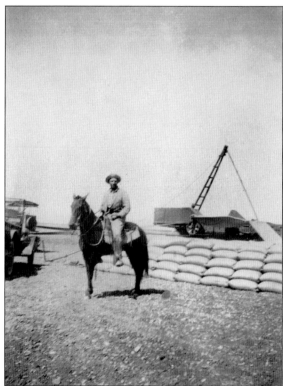

This early-1900s photograph shows Orin Weston on his horse alongside stacked bags of lima beans before getting ready to take them to market. (Courtesy Torrance Historical Society and Museum.)

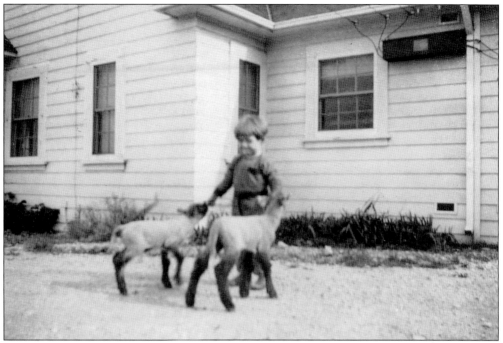

Little Benjamin Price Weston is pictured here with some of the young goats on the Weston Ranch in Torrance. He was born in 1892, and his father, Orin, named him after his uncle, Benjamin Stone Weston, the founder of Weston Ranch. (Courtesy Torrance Historical Society and Museum.)

This early-1900s photograph shows Benjamin P. Weston (right) and a young friend at the Weston Ranch barn all dressed up and both appearing a bit unhappy at having their photograph taken. (Courtesy Torrance Historical Society and Museum.)

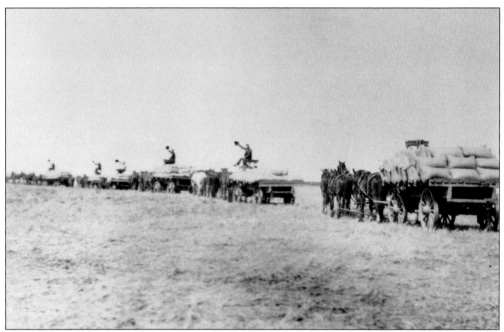

Weston Ranch hands are seen celebrating with a wave of their hats as they take sacked and loaded wagons of barley to market. Barley, beans, and other oats were either taken to Wilmington for shipment by boat or to the train station in Redondo Beach to be shipped. (Courtesy Paul R. Comon Collection.)

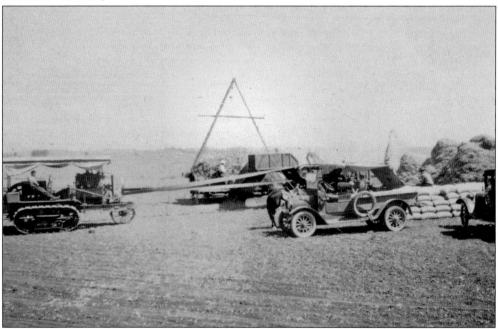

Weston Ranch hands loaded beans, barley, and other oats onto these horse-drawn threshing machines to separate the grains from the stalks and husks. Although it is hard to believe now, these early, automated machines took much of the drudgery out of farm labor by eliminating the need to separate the grain by hand with flails. (Courtesy Torrance Historical Society and Museum.)

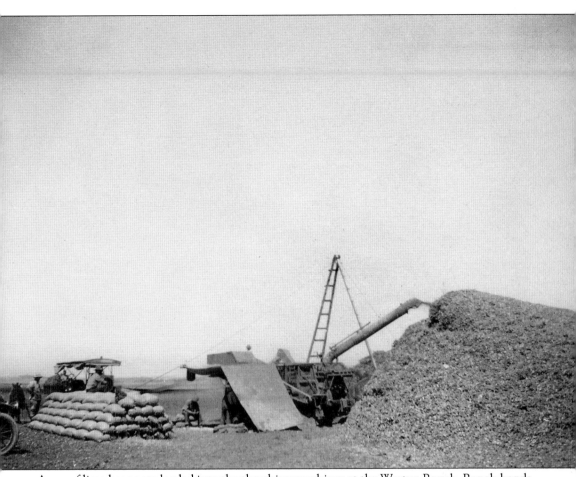

Acres of lima beans are loaded into the threshing machines at the Weston Ranch. Ranch hands sitting atop bags of already threshed beans can be seen resting on the left. (Courtesy Torrance Historical Society and Museum.)

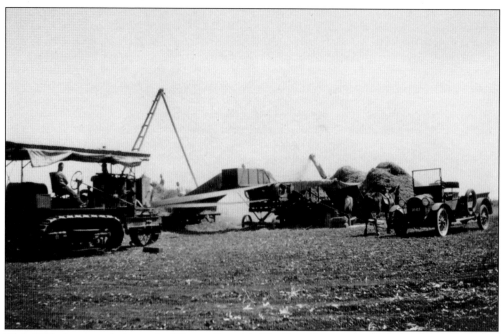

This 1912 photograph shows the Weston Ranch's "Big Betsy" in action. It was an early threshing machine that allowed ranch hands to fasten bags of harvested grain to it for threshing. This was a method used at Weston Ranch and other area ranches in the area. (Courtesy Torrance Historical Society and Museum.)

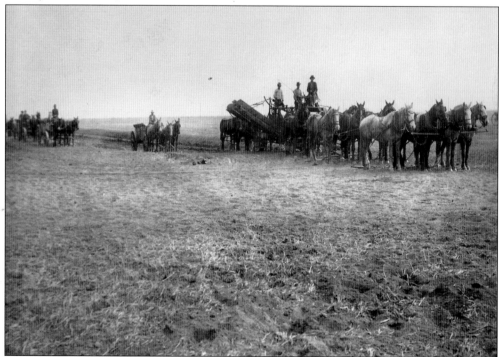

This 1912 photograph shows teams of horses carrying men and materials in an early road-building effort on the Weston Ranch. (Courtesy Torrance Historical Society and Museum.)

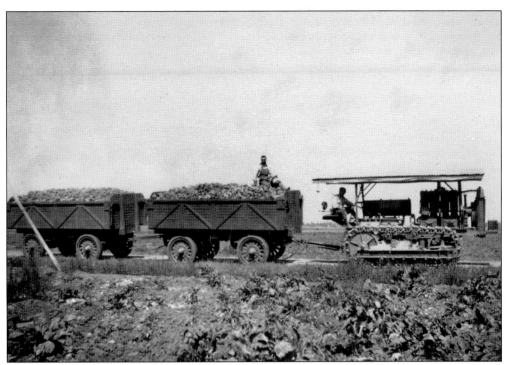

Sugar beets were another large commodity in the Torrance area during the early part of the 20th century. Weston Ranch workers are seen in these 1912 photographs hauling sugar beets for processing. The sugar beet crops in the area were sold to the Holly Sugar Company. (Both courtesy Torrance Historical Society and Museum.)

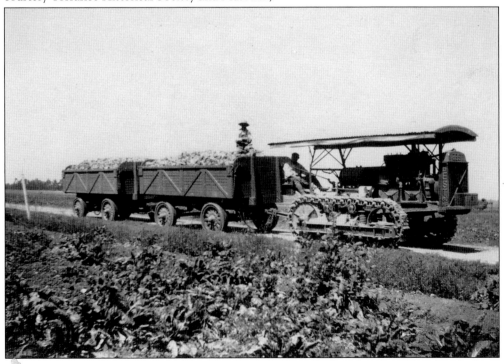

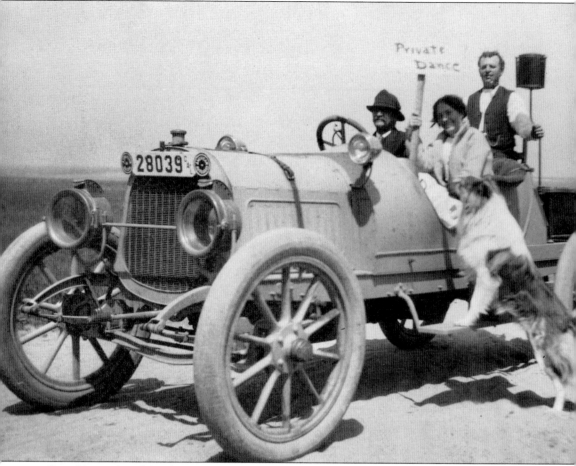

Orin (driving) and Sarah Weston are pictured with an unidentified man in about 1912 driving around the Weston Ranch in this Stutz motorcar. The Stutz Motor Company produced their first car in 1911. Notice the right-hand drive steering wheel, as well as Sarah's "Private Dance" sign and the Auto Club of Southern California ornament attached to the California license plate. (Courtesy Torrance Historical Society and Museum.)

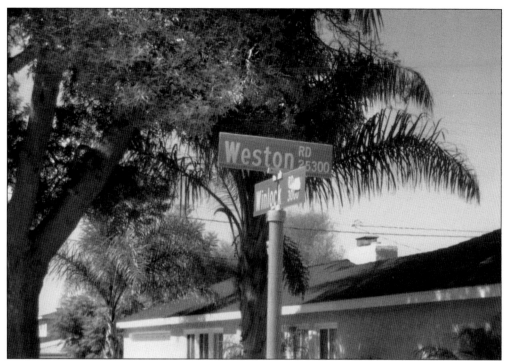

The Weston Ranch house was about one-half mile south of present-day Pacific Coast Highway, at about the 2900 block, in south Torrance. Today this Weston Road sign is all that remains of the 3,000-acre Weston Ranch. (Courtesy author.)

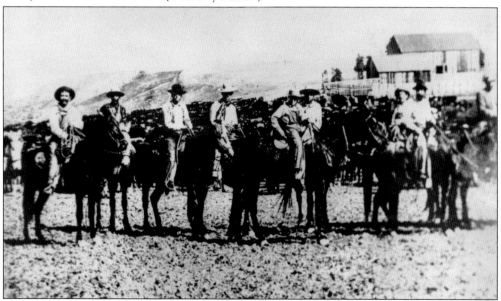

This 1911 photograph shows real-life cowboys working on the ranch lands in the Palos Verdes Hills, at either the Palos Verdes Ranch or the Weston Ranch. Large cattle herds grazed in the Palos Verdes Hills until spring, when Weston and other ranch cowhands would round them up and drive them to a large corral at present-day Pacific Coast Highway and Crenshaw Boulevard. (Courtesy Torrance Historical Society and Museum.)

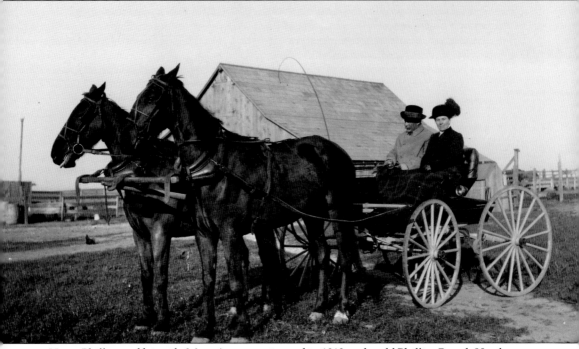

Harry Phillips and his wife, Mary Ann, are pictured in 1912 at the old Phillips Ranch Headquarters on the Palos Verdes Peninsula. Harry Phillips, who managed the area for a Bixby heir from 1894 to 1913, was hired to develop the 16,000-acre Bixby land known as the Palos Verdes Ranch, which bordered the Weston Ranch in Torrance. Phillips raised horses, cattle, and produce, and there was a great demand for the barley, hay, oats, and vegetables grown there. (Courtesy Palos Verdes Library Local History Collection.)

Harry Phillips Jr. poses while sitting on his horse, Bird, in this 1912 photograph. After graduating from the University of Southern California (USC) in 1912, Phillips Jr. took over the 500-acre farm (near the Palos Verdes Golf Club) from John Fritz, who had farmed it for the Bixbys. He raised barley and 200 acres of lima beans. He and his wife, Hilda, lived where the golf course is now. (Courtesy Palos Verdes Library Local History Collection.)

In these 1915 photographs, ranch hands at the Phillips Ranch are getting sheep ready for market. This was done by putting them into a weighing machine. The weighing machine was used for cattle and other livestock as well. (Both courtesy Palos Verdes Library Local History Collection.)

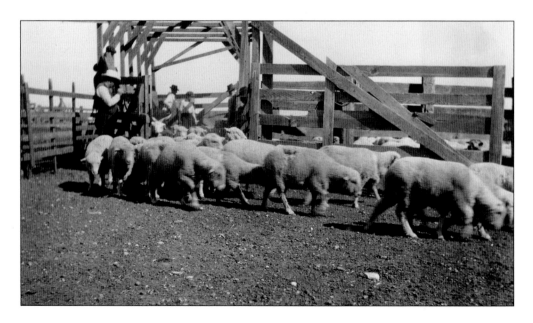

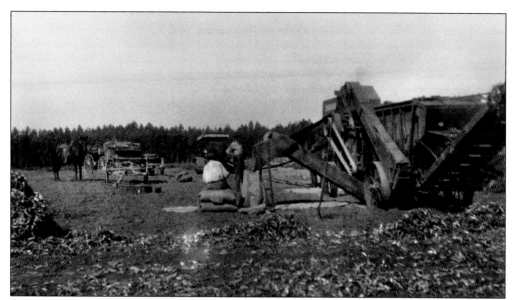

In 1916, workers at the Harry Phillips Ranch on the Palos Verdes Peninsula operate the mechanical thresher to separate lima beans and prepare them for market. The ranch was located near Blackwater Canyon to the northeast of the present intersection of Palos Verdes Drive North and Rolling Hills Road in Rolling Hills Estates. (Courtesy Palos Verdes Library Local History Collection.)

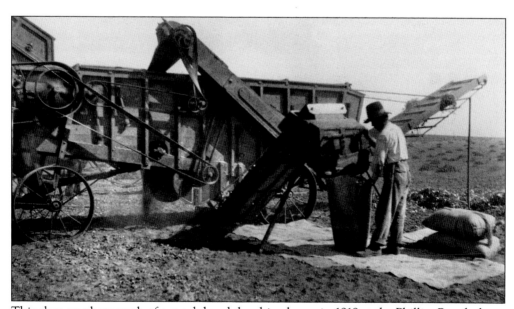

This close-up photograph of a ranch hand threshing beans in 1918 at the Phillips Ranch shows how time consuming a task it was to load the beans into individual bags. (Courtesy Palos Verdes Library Local History Collection.)

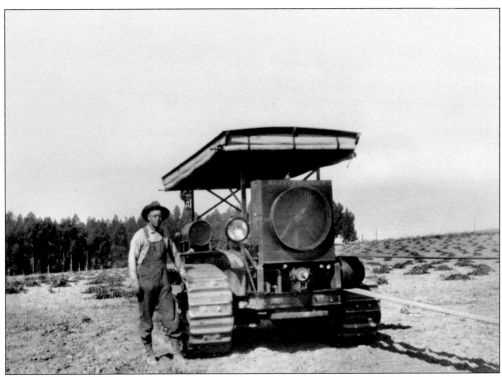

Harry Phillips Jr. proudly poses beside this 45-horsepower Caterpillar in 1915 at his Rolling Hills Ranch. Notice the name Harry Phillips painted across the top of the machine. (Courtesy Palos Verdes Library Local History Collection.)

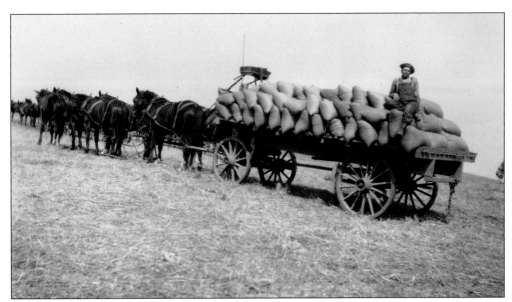

In 1915, Harry Phillips Jr. poses for a photograph at the Phillips Ranch in Rolling Hills with a load of barley that has been put onto horse-drawn wagons to get it ready for hauling to the milling company in Redondo Beach. (Courtesy Palos Verdes Library Local History Collection.)

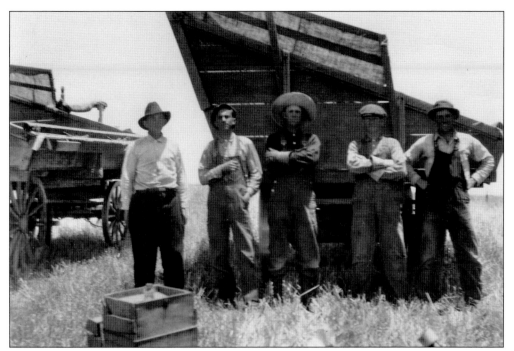

Jack Phillips (center) and ranch hands take a break from threshing beans on the Harry Phillips Ranch to pose in front of the threshing machinery for this 1915 photograph. (Courtesy Palos Verdes Library Local History Collection.)

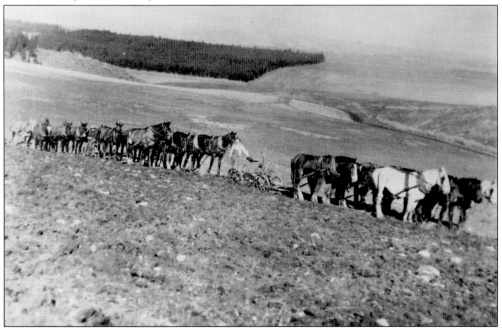

Ranch hands at the Weston and Phillips Ranches would use horses to pull the farm equipment, including the cultivators, plows, mowing machines, rakes, and harvesters. All of this equipment was used to get the fields ready for planting the next crop of beans, sugar beets, oats, or barley. (Courtesy Paul R. Comon Collection.)

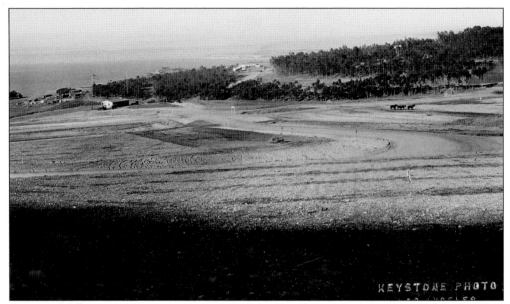

This is a 1915 photograph of the Raymond McCarrell Ranch on the Palos Verdes Peninsula. The McCarrell family was among the dry farmers who grew grains and beans and were very successful. For example, in September 1946, they harvested 3,000 acres of dried beans, lima beans, and garbanzo beans. The ranch is seen here on Malaga Cove, with the Santa Monica Bay and eucalyptus trees visible on what is now Palos Verdes Boulevard. The low place in the left center of the photograph is Topanga Canyon. (Courtesy Palos Verdes Library Local History Collection.)

This photograph of the Raymond McCarrell Ranch in 1915 is looking north. Visible on the right-hand side is Palos Verdes Boulevard along the grove of eucalyptus trees, with the ranch and farm fields at left and the Santa Monica Bay in the background. McCarrell, along with his twin brother, Roy, farmed on the Palos Verdes Peninsula from the early 1900s through the 1950s. They also had a big white barn and residence on the southwest corner of Crest Road and Crenshaw Boulevard that stood until the 1970s. (Courtesy Palos Verdes Library Local History Collection.)

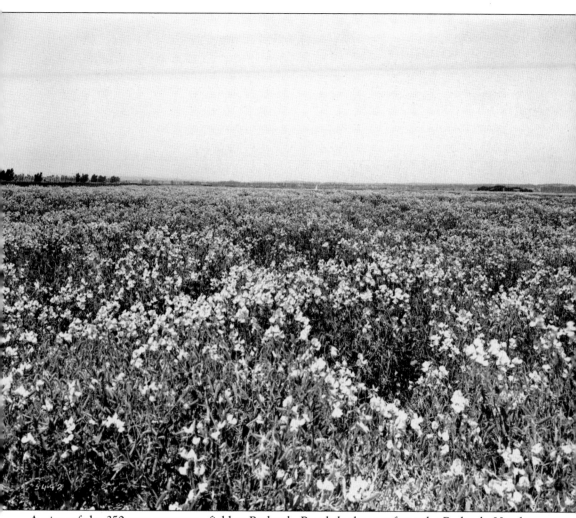

A view of the 350-acre sweet pea field at Redondo Beach looks east from the Redondo Hotel (operating around 1904–1913). When it flourished, the field produced 27 tons of seeds. The field is covered with tall stalk flowers. Buildings and trees scattered across the landscape are visible in the distance. (Courtesy USC Special Collections/Regional History Collection.)

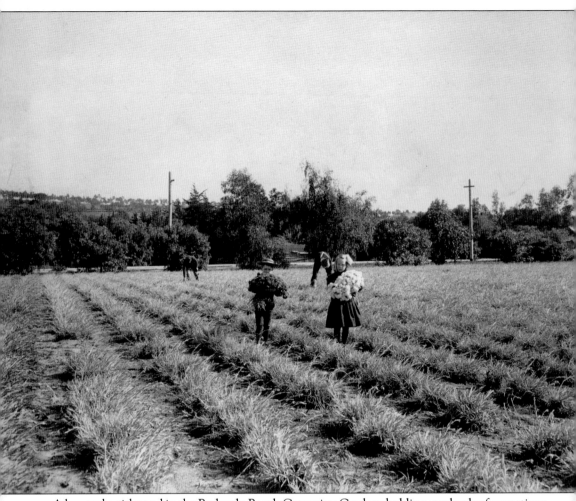

A boy and a girl stand in the Redondo Beach Carnation Gardens holding armloads of carnations in this 1910 photograph. In 1902, William Wolfskill planted the 12-acre carnation gardens east of the Hotel Redondo as a tourist attraction. The gardens were sold off beginning in 1913 as residential lots. At its peak, the garden boasted shipments of 10,000 carnations a day. (Courtesy USC Special Collections/Regional History Collection.)

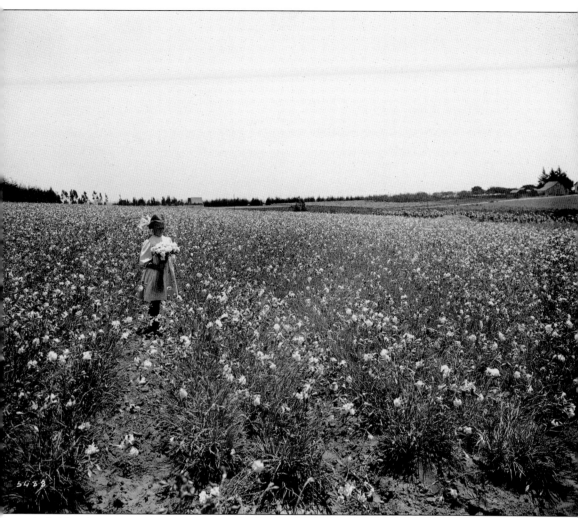

A child picks carnations in a carnation field in Redondo Beach in a view looking east from the Hotel Redondo. An *LA Times* article from May 14, 1901, indicated that nearly 100,000 carnations were shipped from the Redondo Gardens for the Los Angeles Fiesta that year. (Courtesy USC Special Collections/Regional History Collection.)

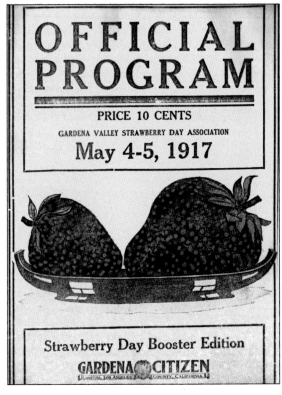

BANQUET

GIVEN BY THE

GARDENA VALLEY
STRAWBERRY DAY ASSN.
RACE COMMITTEE*

TO THE

OFFICIALS
OF THE
STRAWBERRY DAY TROPHY

WHICH WAS HELD AT

GARDENA MAY 6, 1916.

JUNE 2, 1916. CLUB HOUSE
GARDENA, CAL.

Gardena was once known as "Berryland" for its production of strawberries, blackberries, and raspberries. The annual Strawberry Day Festival was held each May and was well attended: the *LA Times* reported that 10,000 people attended the 1916 event. The festival featured a parade, a concert by the Gardena High School orchestra, a livestock exhibit, a poultry show, a gardening exhibit, a floral parade, a rodeo, the crowning of the Strawberry Queen, and a free box of strawberries for each visitor. The berry industry's decline after World War I was due to community development and the shift to other crops, including barley and alfalfa. Stories have circulated that for several years, the Hotel Redondo purchased all the berries the farmers could grow for its tables. (Both courtesy Gardena City Clerk's Office.)

OFFICIAL
PROGRAM

PRICE 10 CENTS

GARDENA VALLEY STRAWBERRY DAY ASSOCIATION

May 4-5, 1917

Strawberry Day Booster Edition

GARDENA CITIZEN

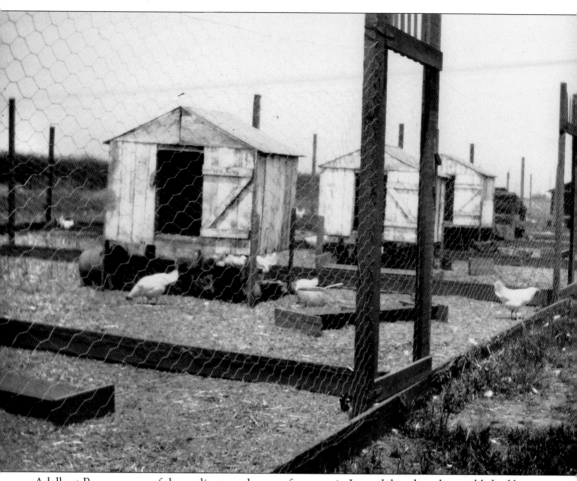

Adelbert Buss was one of the earliest purchasers of acreage in Lawndale, where he established his ranch in 1908 and built a home in 1909. This 1910 photograph shows the ranch's poultry operation, which at the peak of its production owned 3,000 laying hens. (Courtesy James Osborne.)

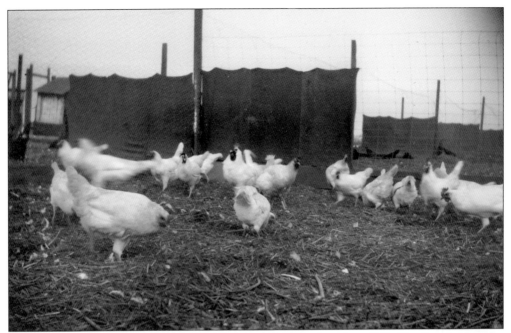

Pictured here a flock of white leghorn hens roaming the Buss Ranch in 1910. City founder Charles Hopper marketed Lawndale as an ideal place to raise chickens. He promoted his concept of the "Lawndale Poultry Colony" in the early 1900s and even had a model chicken ranch built to encourage others to come to "Lawndale Acres." (Courtesy James Osborne.)

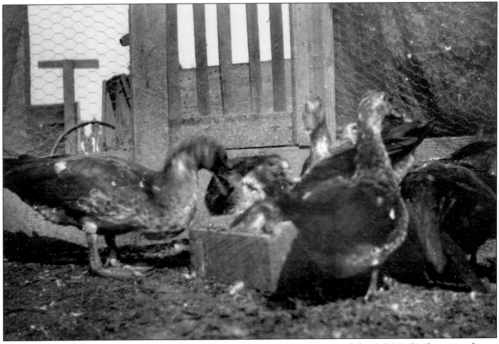

These ducks at Adelbert Buss's Lawndale Ranch in 1910 were part of the 3,000 chickens, turkeys, and milking cows that he raised, and they showed that he was doing his part to make Charles Hopper's vision for Lawndale Acres come true. (Courtesy James Osborne.)

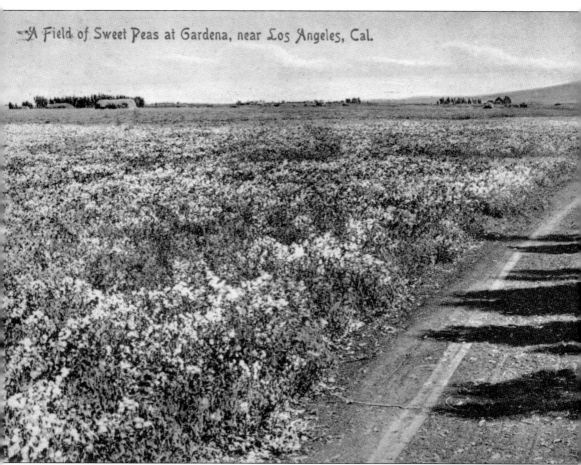

A Field of Sweet Peas at Gardena, near Los Angeles, Cal.

In 1904, Englishman John Bodger bought 160 acres in Gardena that became known as the Sweet Pea Farm, which was managed by his son Walter Bodger. When advertisements about the Sweet Pea Farm began appearing in Los Angeles newspapers and large banners were displayed on the Pacific Electric Red Cars, Walter had to don his deputy sheriff's badge to control the sometimes thoughtless crowds who carelessly trampled through the fields. (Courtesy James Osborne.)

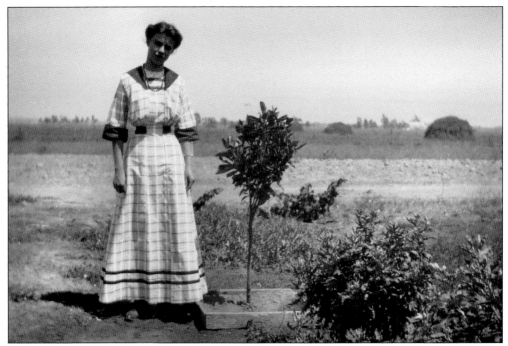

In this 1910 photograph, Helen Buss poses beside a young magnolia tree at the Buss Ranch in Lawndale. The ranch was located across from the Bodger flower farm. It can be seen behind her along what is present-day Prairie Avenue. (Courtesy James Osborne.)

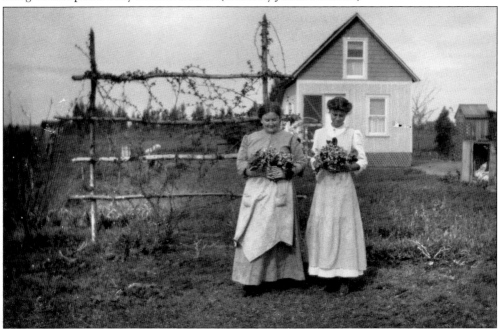

Helen Buss (right) and her cousin Clara Newell hold bouquets of just-picked sweet peas from the Bodger Sweet Pea Farm. In the early days of the farm, the Bodgers would let friends and neighbors come and pick flowers whenever they pleased as long as they were careful not to trample the plants. (Courtesy James Osborne.)

This old mule stands inside the Bodger Seed Farm near Prairie Avenue in this 1910 photograph. When the Bodgers moved their sweet pea growing operations to the Lompoc Valley in the late 1920s, hay was grown on this Lawndale area farm. It was then leased to Japanese truck gardeners before it was sold and subdivided for housing in the early 1950s. By the 1930s, when it moved its office headquarters to El Monte, Bodger Seeds was one of the largest flower growers in the world and remains so today. (Courtesy James Osborne.)

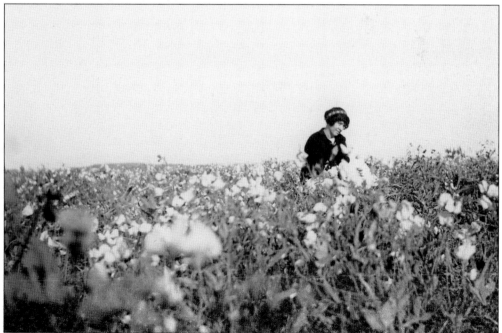

Nellie Dickey, family friend of Helen Buss, picks sweet peas from the Bodger Sweet Pea Farm in 1912. (Courtesy James Osborne.)

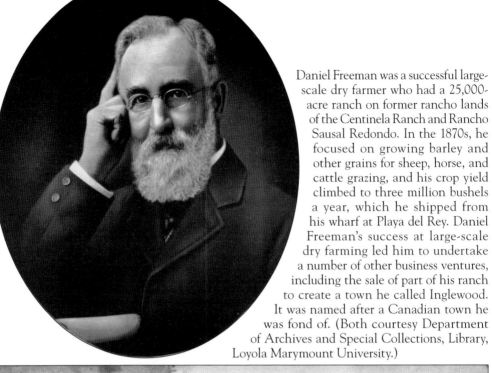

Daniel Freeman was a successful large-scale dry farmer who had a 25,000-acre ranch on former rancho lands of the Centinela Ranch and Rancho Sausal Redondo. In the 1870s, he focused on growing barley and other grains for sheep, horse, and cattle grazing, and his crop yield climbed to three million bushels a year, which he shipped from his wharf at Playa del Rey. Daniel Freeman's success at large-scale dry farming led him to undertake a number of other business ventures, including the sale of part of his ranch to create a town he called Inglewood. It was named after a Canadian town he was fond of. (Both courtesy Department of Archives and Special Collections, Library, Loyola Marymount University.)

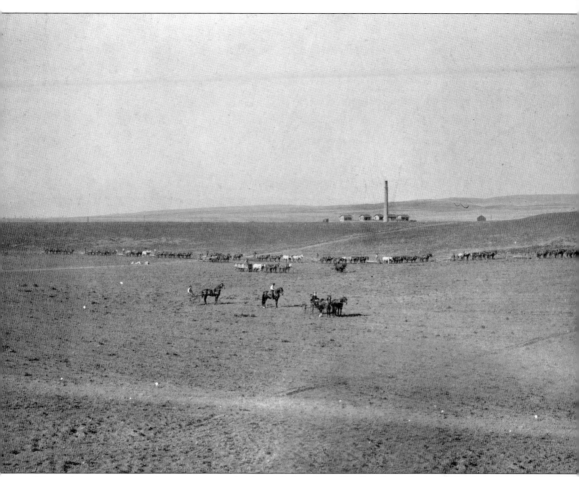

Horse-drawn wagons and carriages move both ranch hands and barley through the fields of the Daniel Freeman Ranch in preparation for shipping the grains at Freeman's Playa del Rey wharf. (Courtesy Department of Archives and Special Collections, Library, Loyola Marymount University.)

This photograph of Daniel Freeman's ranch provides a view of the orchard with its citrus, almond, olive, and eucalyptus trees. Both the Freeman House and the barn are visible at the rear of this undated photograph. Today his land office is located at the Centinela Adobe, a museum that is dedicated to Freeman. (Courtesy Department of Archives and Special Collections, Library, Loyola Marymount University.)

Two

AGRICULTURAL HEYDAY
1920 THROUGH WORLD WAR II

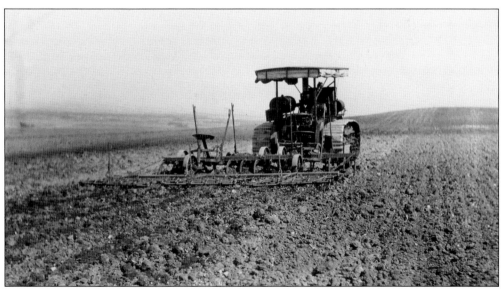

This is a 1920 panoramic view of the Phillips North Ranch looking across agricultural fields with hills in the background and scattered hay visible in the foreground. This machine was used for discing and harrowing on the north slopes of the ranch. (Courtesy Palos Verdes Library Local History Collection.)

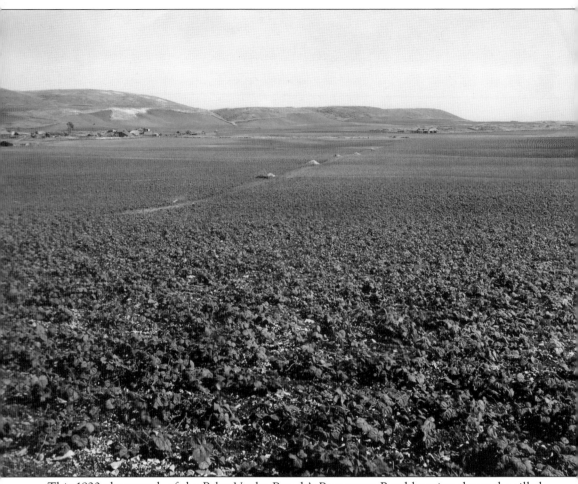

This 1920 photograph of the Palos Verdes Ranch's Portuguese Bend location shows the tilled fields and the ranch headquarters in the middle of the cluster of buildings. (Courtesy Palos Verdes Library Local History Collection.)

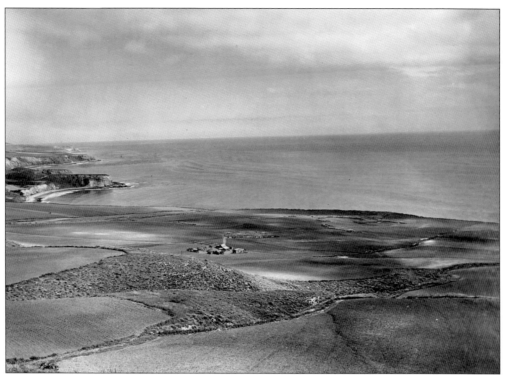

A 1923 view of soybean fields in the Portuguese Bend area of the Palos Verdes Peninsula looks north across cultivated agricultural fields. If one looks closely, a farmhouse, barn, and mule team are all visible in the distance. (Courtesy Palos Verdes Library Local History Collection.)

In the late 1920s, the Palos Verdes Peninsula developed a squirrel problem. Since it was during the Depression, unemployed men were hired under a WPA program by the county agricultural commissioner's office to help eradicate them. (Courtesy Los Angeles Agriculture Commissioner.)

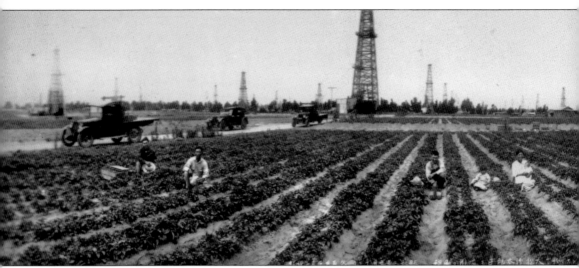

This 1927 photograph features Bob (in his mother's arms) and Marian Omatsu (sitting between her parents) and their parents, father Sakumatsu (in overalls) and mother Hanayo, on the Torrance strawberry farm. Their farm was located on Hawthorne Boulevard between Carson Street and

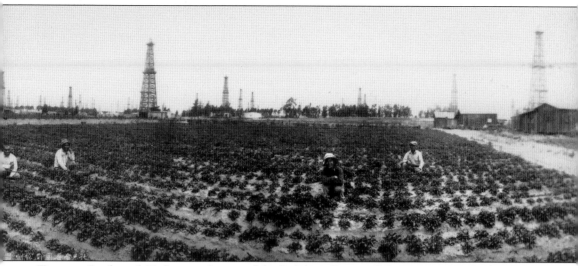

Torrance Boulevard. Today it is the site of the Del Amo Financial Center, approximately where the Doubletree Hotel is located. (Courtesy Torrance Historical Society and Museum.)

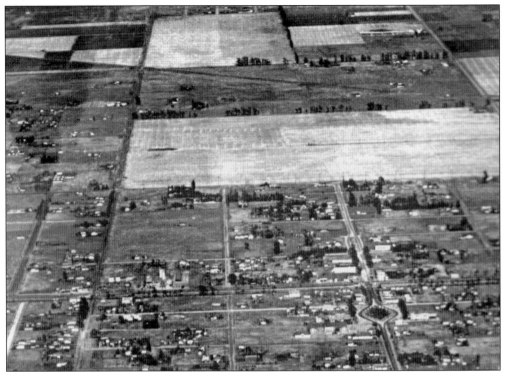

A 1929 aerial overview of the Bodger Seed Farm shows a portion of the 350 acres that the John Bodger family planted with sweet peas, located in present-day Hawthorne, bordered by Rosecrans, Prairie, and Yukon Avenues and Manhattan Beach Boulevard, with Marine Avenue dividing the ranch. When it opened in 1904, the seed farm was originally considered to be in Gardena, but it was redistricted into Lawndale in 1913. Later the land was annexed into Hawthorne after homes were built on it during the early 1950s. (Courtesy James Osborne.)

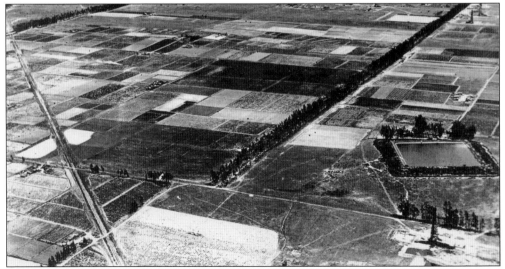

Even though the City of Torrance was incorporated in 1921, this 1923 aerial photograph of Torrance clearly shows the large percentage of acreage that was still devoted to agricultural activities in the city at that time. (Courtesy Torrance Historical Society and Museum.)

This 1932 photograph is of Torrance mayor William Klusman sporting his trademark silk top hat. Klusman was an eccentric character who ran for office 10 times before finally being elected and was appointed mayor in 1932, only to be removed from office a year later. Aside from being a self-proclaimed socialist, he had a chicken ranch in Lomita, on West 253rd Street near Walnut Street. (Courtesy Torrance Historical Society and Museum.)

In 1930, the development of housing tracts can be seen in this aerial photograph of homes and farmland in the Walteria section of Torrance. The diatomaceous earth mine site is barely visible in the top right-hand corner of the picture. Garnet Sidebotham started the mine in 1917, and it was the only earth mining operation in Torrance. (Courtesy Special Collections and Archives, California State University, Dominguez Hills.)

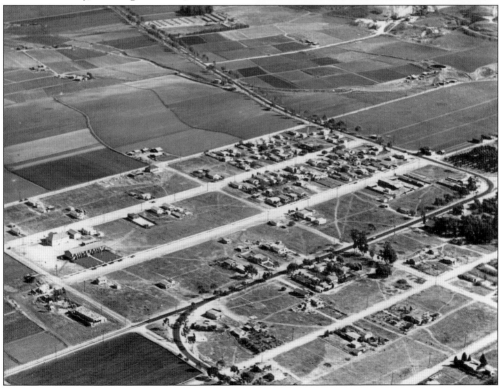

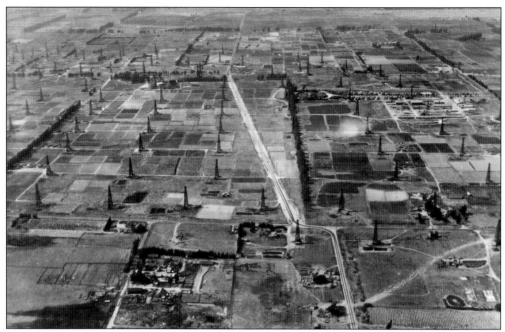

This 1931 overview looks north over Anza Boulevard at rows of wooden oil derricks among acres and acres of crop fields, including beans, barley, and assorted vegetables, and several large ranches in southwest Torrance. (Courtesy Special Collections and Archives, California State University, Dominguez Hills.)

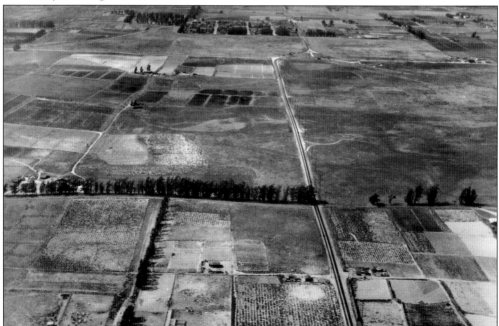

This 1931 overview shows a large cattle ranch in the foreground with a livestock ranch and fields of crops with rows of trees along a road in south Torrance, believed to be near present-day Anza Avenue and Pacific Coast Highway. (Courtesy Special Collections and Archives, California State University, Dominguez Hills.)

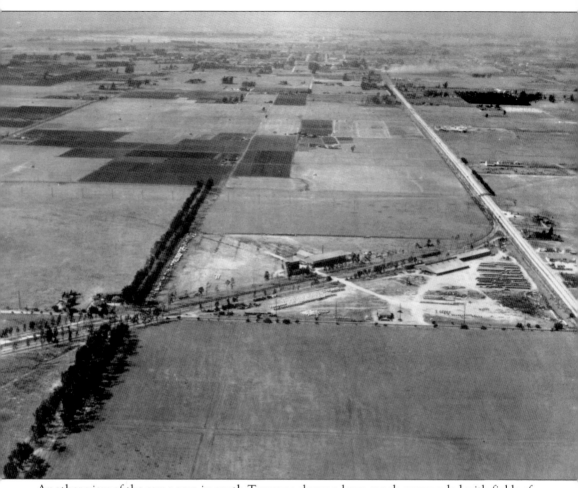

Another view of the same area in south Torrance shows a large ranch surrounded with fields of grains and beans, which remained one of the top commodities in the area through the 1970s. (Courtesy Special Collections and Archives, California State University, Dominguez Hills.)

Although the Vaccaro family became better known for their Mira Loma Turkey Ranch, they first started farming in Torrance in 1918, when David Vaccaro began growing asparagus under the Mira Loma label. Mira Loma brand asparagus was sold at the LA Produce Market in downtown Los Angeles. This 1930s photograph shows an asparagus patch located in front of cypress trees planted as a wind break. Their farm was located parallel to Victor Street where Entradero Street is today. (Courtesy Vaccaro family.)

The Mira Loma Asparagus Farm not only had a corn patch in the back but also an oil derrick. One oil derrick was allowed on each five-acre parcel of land and the oil companies paid the Vaccaro family royalties for the oil pumped from these derricks. The oil derricks were located at the corners of Henrietta and Emerald Streets, Henrietta and Spencer Streets, Spencer and Victor Streets, and Victor and Emerald Streets in Torrance. (Courtesy Vaccaro family.)

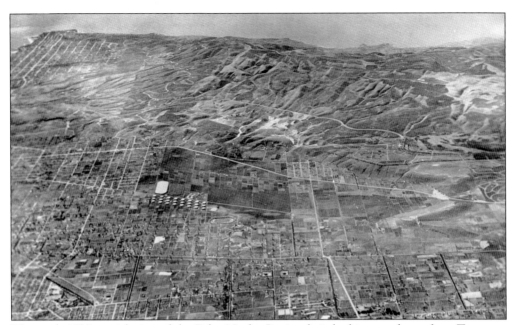

This early-1930s aerial view of the Palos Verdes Peninsula is looking southeast from Torrance. The Los Angeles Harbor is visible on the left all the way to Long Point on the right. Palos Verdes Drive East and North are also visible along the hillside. Also visible in the center are the many farms in the Walteria section of Torrance near Crenshaw Boulevard and Pacific Coast Highway. (Courtesy Palos Verdes Library Local History Collection.)

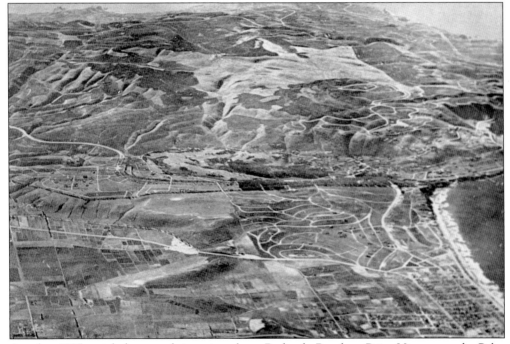

Another 1935 aerial photograph is a view above Redondo Beach to Point Vicente on the Palos Verdes Peninsula. While Redondo Beach shows many beach cottages and homes, the Torrance area shown on the left is all farmland. (Courtesy Palos Verdes Library Local History Collection.)

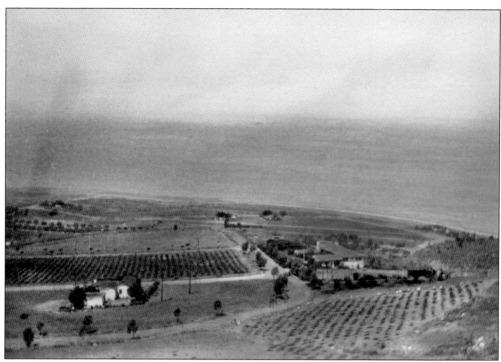

This hand-colored postcard image shows an aerial view of the coastal farming along the west side of the Palos Verdes Peninsula. (Courtesy Palos Verdes Library Local History Collection.)

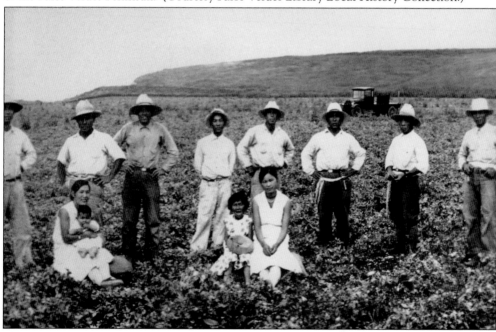

The Sumi-Hiraga families farmed in the Lunada Bay area of Palos Verdes Estates and are pictured here in their fields in this 1931 photograph. There were over 40 Japanese American families that leased land on the Palos Verdes Peninsula from the early 1900s through World War II. (Courtesy Palos Verdes Library Local History Collection.)

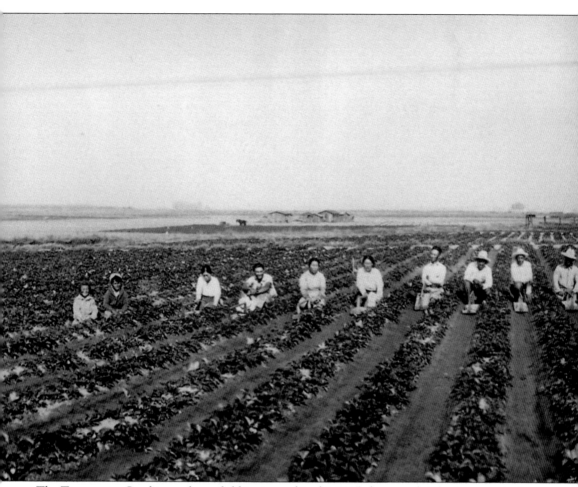

The Tsunematsu Sasaki strawberry field is pictured in this 1935 photograph. The farm was in the Carson area near present-day 223rd Street and Avalon Boulevard. The young boy pictured second from the left is Harry Sasaki. There were six families that worked this leased land, including the Tsunematsu Sasaki and Takuichi Shintaku families. (Courtesy Kiyoshi "Harry" Sasaki.)

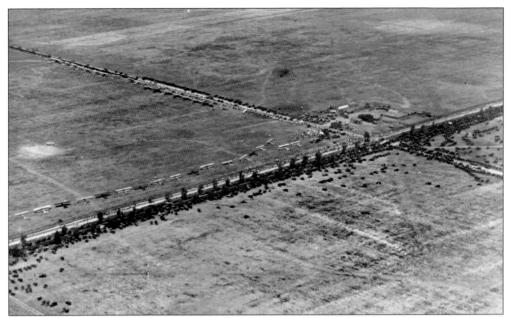

This photograph dated August 24, 1926, is an aerial view of Inglewood Field on the Bennett Rancho, which Andrew Bennett farmed from the 1890s through the 1920s. By 1922, Bennett had 3,000 acres and was growing wheat, barley, and lima beans. Bennett's bean and barley field at Inglewood-Redondo Road and Imperial Highway became Mines Field, which would later become Los Angeles International Airport. (Courtesy Los Angeles World Airports Photo Archives.)

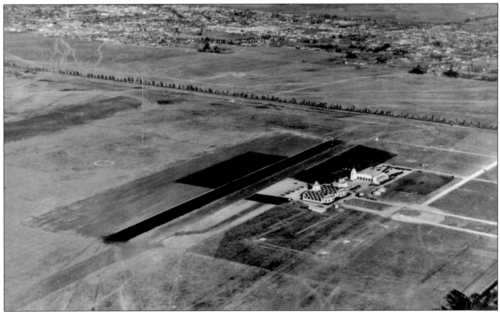

In this 1929 photograph, the buildings at Mines Field can be clearly seen in this northeast view along Redondo Boulevard. During the 1920s, pioneer aviators were attracted to the Bennett Rancho and used part of it as a crude landing strip. Soon they were attracting crowds, and in 1927, a group of local citizens pushed for the development of a major airport on this part of the Bennett Rancho. (Courtesy Los Angeles World Airports Photo Archives.)

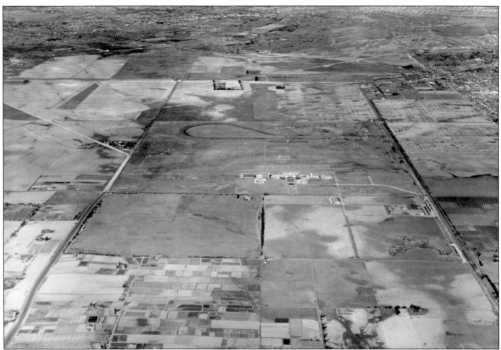

These aerial photographs of Mines Field are from November 1934. In 1927, the City of Los Angeles became interested in creating a municipal airport, and real estate agent William W. Mines offered them 640 acres of the Bennett Rancho. As a result, in July 1928, Mines Field was chosen as the location for the city's airport, known today of course as LAX. (Both courtesy Los Angeles World Airports Photo Archives.)

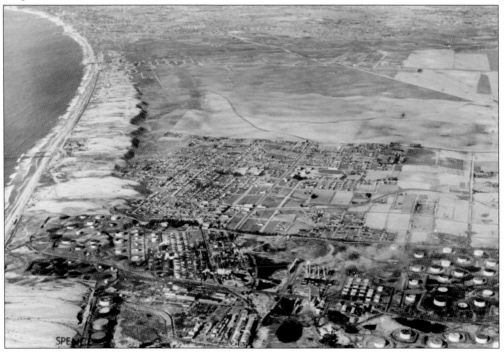

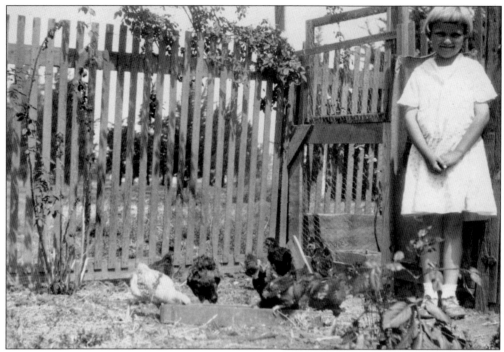

Laura Thomas, Adelbert Buss's granddaughter, is pictured alongside these small chickens, known as bantams, as they feed in this 1935 photograph at the Buss Ranch in Lawndale. (Courtesy James Osborne.)

Laura Thomas poses with Fawn, one of the Buss family's calves at the family ranch in Lawndale in the late 1930s. (Courtesy James Osborne.)

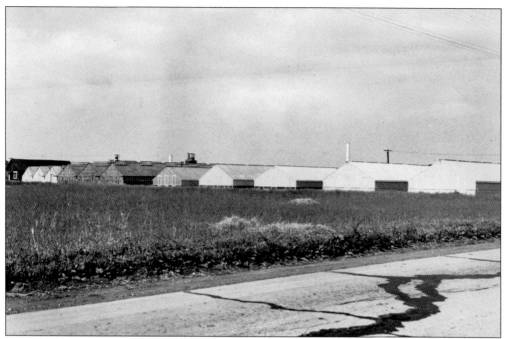

T. H. Wright was an orchid and gardenia grower who had greenhouses on Dominguez Street (now known as 190th Street) and Hawthorne Boulevard in Torrance. Beginning in 1907, Wright raised orchids and gardenias for export and adopted a new method of growing that allowed him to cut production time from 10 years to five years, and he was getting four crops a year instead of just one. He used artificial methods including artificial food, light, heat, and refrigeration. His method was so successful that by 1936, half of all New York's gardenias and 9 or 10 of those used in Los Angeles were grown in Torrance. Wright produced five million gardenias a year. (Both courtesy Security Pacific Collection/Los Angeles Public Library.)

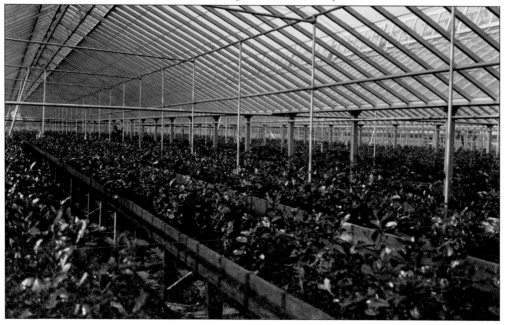

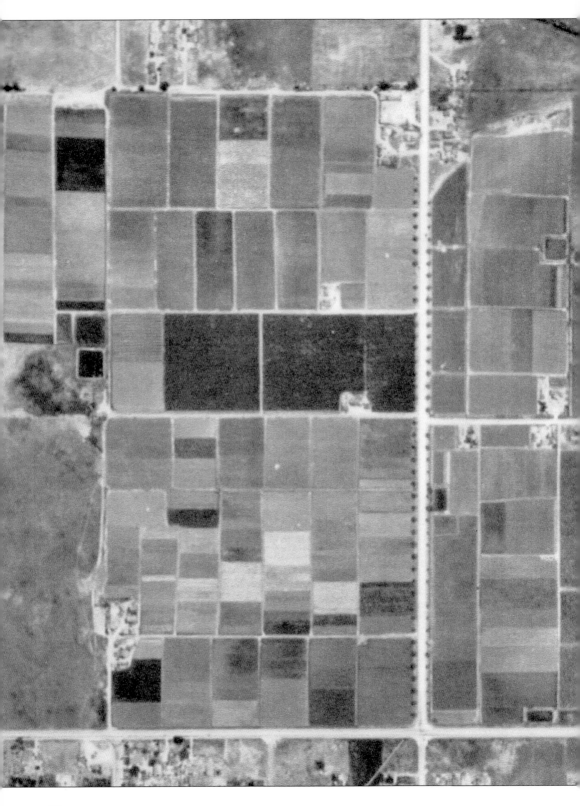

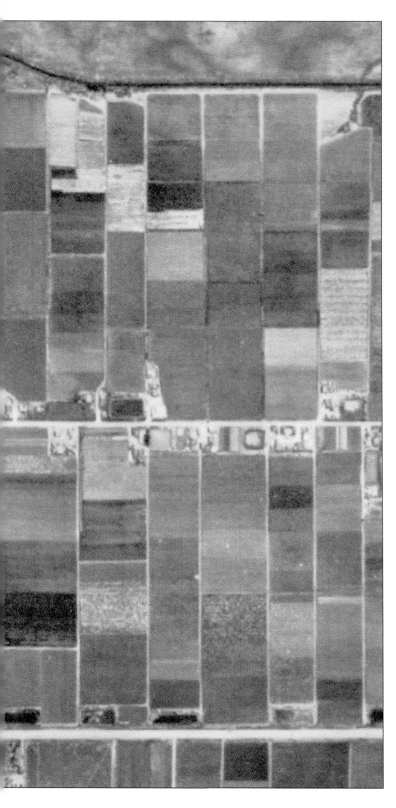

This aerial photograph from August 30, 1941, is an overview of all of the Japanese farms in Lawndale just before World War II and before they were interned during the war. Lawndale's former Japanese residents were first transported to the Santa Anita racetrack in Arcadia, California, and kept there in horse stalls before being interned at Rowher, Arkansas. (Courtesy James Osborne.)

Benj. P. Weston

1222 WILSHIRE BOULEVARD
LOS ANGELES
CALIFORNIA

February 18, 1942

P. O. Box 449
Torrance, California

Mr. W. S. Rosecrans,
Chamber of Commerce Bldg.,
Los Angeles, California

Dear Mr. Rosecrans:

 I understand that you have recently been appointed
Agriculture Coordinator by the Board of Supervisors. I want
to take this opportunity to congratulate you on this appointment
as I have thought of you many times recently regarding the farm
problem which we are now confronted with. I recall that it was
during the last war that I had the pleasure of working with you
in connection with the Farm Bureau.

 The Weston Investment Company still has a large amount
of acreage in the City of Torrance which is being cultivated by
American born Japanese who grow vegetables and flower stock.
This situation, therefore, has been of considerable concern to me
and I have patiently awaited legislation which might affect this
area.

 I am living on the ranch on 101 Highway, one-half mile
west of Lomita, and I would appreciate hearing from you at your
earliest convenience and hope that I might be of assistance to
you in this area. My telephone number is Lomita 1313 and the
mailing address is P. O. Box 449, Torrance.

Very truly yours,

Benj. P. Weston

This 1942 letter from Benjamin P. Weston to W. S. Rosecrans shows that Weston did return to the Torrance area after moving to Los Angeles in the 1920s. He did this because he still had a large amount of land leased to Japanese American farmers who grew vegetables and flower stock. With Rosecrans in charge of deciding what to do with the land of the Japanese farmers who were interned, Weston wanted to make sure his tenants were taken care of properly. (Courtesy Los Angeles County Agriculture Commissioner.)

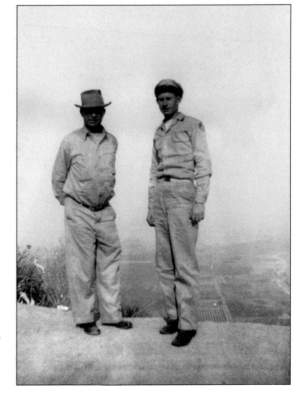

Farmer and World War II fighter pilot Roy Pursche (right) is pictured here with Pursche Ranch foreman Stuart Clarke (left) while on leave in 1945. They are standing on part of the Pursche family's acreage up at the Palos Verdes Ranch, near the area of Palos Verdes Drive South and Twenty-fifth Street. There they dry farmed garbanzo beans and barley. This was in addition to the acreage they had in Gardena and Torrance. (Courtesy Roy Pursche.)

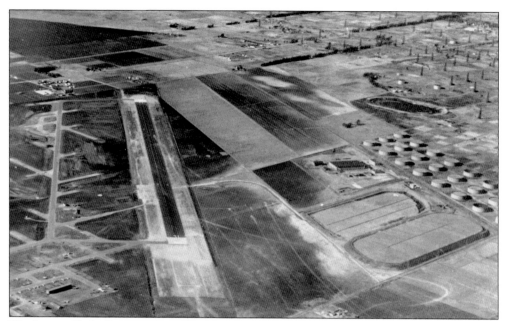

The Lomita Flight Strip is pictured here in December 1945. It is now known as Torrance Airport. Prior to World War II, Ben Weston, who owned the land, leased small plots to tenant farmers. During World War II, the Army Air Corps built an airport on Weston Ranch property, and because it was so close to Lomita on the east side, it became known as the Lomita Flight Strip. The airport remained under cultivation throughout the war. (Courtesy City Manager, City of Torrance.)

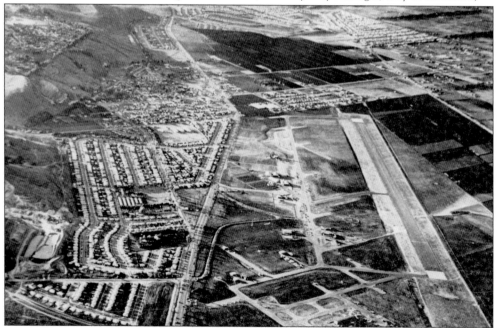

This 1945 photograph shows Pacific Coast Highway and Crenshaw Boulevard near Torrance Airport. In 1946, ownership of the army's flight strip was transferred to the City of Torrance, and the 89-acre property was named Zamperini Field after notable Torrance resident Louis Zamperini. (Courtesy Palos Verdes Library Local History Collection.)

Darel Ormonde, son of Tony and Mary, of Ormonde Dairy poses in 1946 with his dog Rex. The dairy, operated by Tony and Mary Ormonde, was located on Arlington Avenue, now Van Ness Avenue, in Torrance. Notice the haystack, the cow to the right of the truck, the bunkhouse on the left, and the chicken coop to the right of the bunkhouse. (Courtesy David Ormonde.)

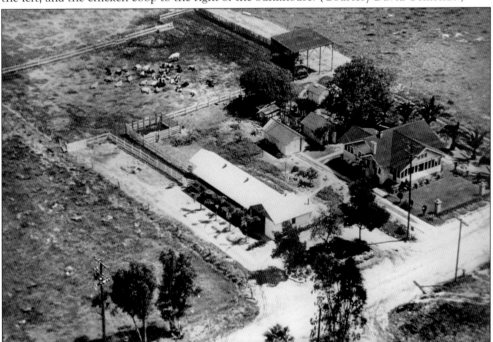

This 1937 overview shows the Peter Pan Dairy, located at 17010 Arlington Avenue, now Van Ness Avenue, in north Torrance. Jake and Marcella Dykzeul owned the three-acre dairy until it was sold to Cecil and Amy Hudson in 1942. (Courtesy Richard Hudson.)

A young Bill Mertz poses for a photograph with a healthy crop of freshly picked cucumbers out in the fields of the Mertz Brothers Farm in Lomita. (Courtesy Bill Mertz.)

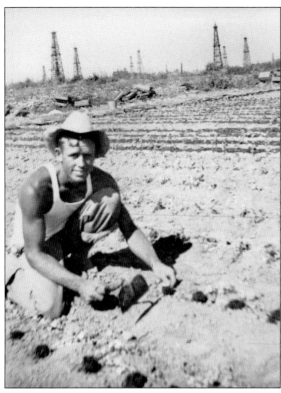

Bill Mertz is pictured here planting in his field using hand tools. Bill and his brother Dick started farming in the late 1930s and grew cucumbers, tomatoes, celery, and corn. They leased 20 acres of Kettler Ranch property in the area known today as Kettler Knolls, near the border of Lomita and Torrance along present-day Western Avenue. (Courtesy Bill Mertz.)

During the early operation at the Mertz Brothers Farm in Lomita, the work was time consuming and laborious, as evidenced by this photograph showing the fields being plowed using a horse-drawn plow. (Courtesy Bill Mertz.)

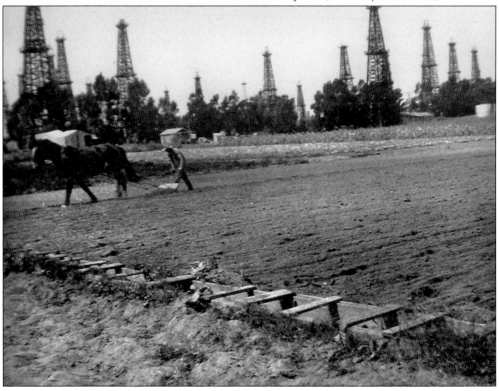

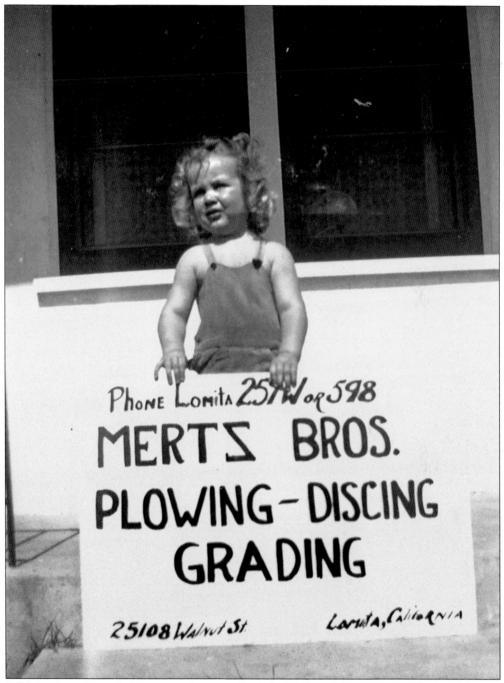

Bill Mertz's son Terry holds a sign advertising his father and uncle's plowing, grading, and discing business, started as a way to supplement the produce farm the two brothers had started in the late 1930s in Lomita. (Courtesy Bill Mertz.)

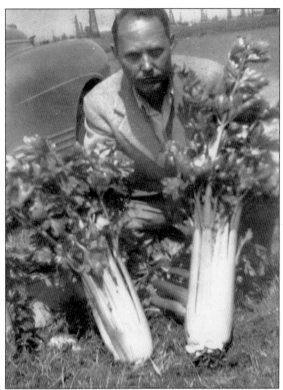

Carl Tasche, the Mertz brothers' partner, proudly poses with some of the farm's large celery at the Mertz Brothers Farm in Lomita. (Courtesy Bill Mertz.)

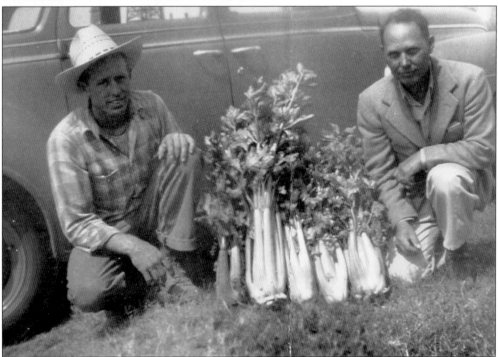

Bill Mertz (left) and Carl Tasche pose with large celery grown by the duo and Bill's brother, Dick Mertz. (Courtesy Bill Mertz.)

In the mid-1940s, the Mertz brothers began to use a new process, soil sterilization, at their Torrance/Lomita farm. They were the first to use this technique and found it produced bigger healthier fruits, vegetables, and plants. (Courtesy Bill Mertz.)

The photograph above, labeled "El Rancho de Conko," is thought to be the 1940s stock ranch of H. G. Conkling. It was located on south Normandie Avenue near the Torrance and Harbor City border. Left, Harry Barnes poses for this March 8, 1949, photograph at El Rancho de Conko. (Both courtesy Torrance Historical Society and Museum.)

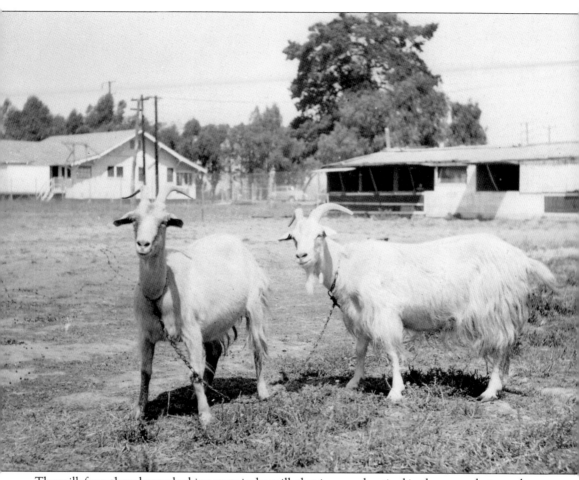

The milk from these happy-looking goats is the milk that is seen advertised in the cover photograph. They belonged to the Conklings, who had a stock farm on south Normandie Avenue. (Courtesy Torrance Historical Society and Museum.)

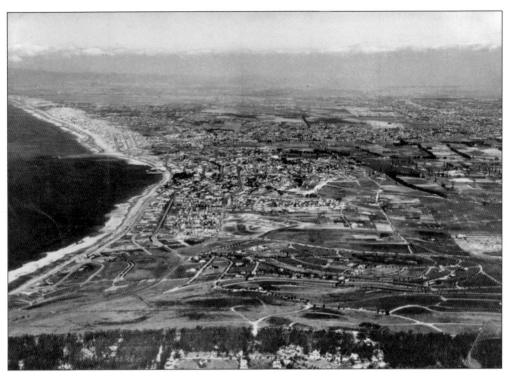

These 1947 aerial photographs of the Hollywood Riviera section of Torrance show its rural roots. Despite being advertised as an enclave for the rich and famous, it was still surrounded by open space and farmland. The oil derricks of Torrance can be seen in the top left corner, and the ocean is visible in the foreground. (Courtesy City Manager, City of Torrance.)

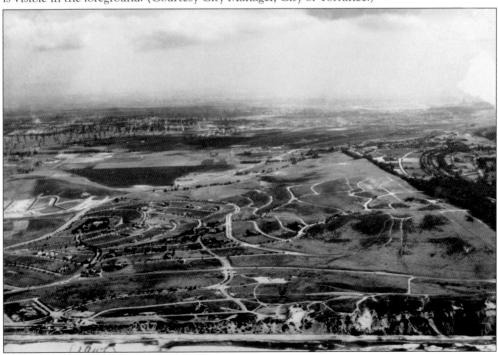

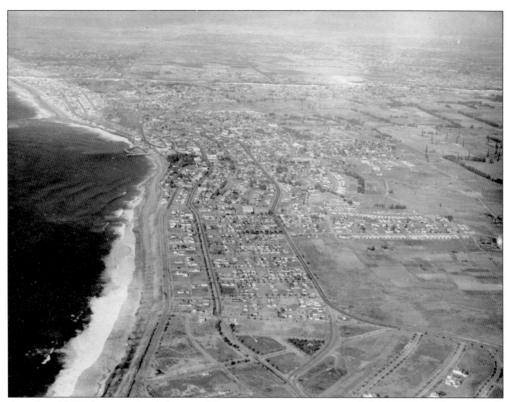

Another 1947 photograph of the west Torrance area gives a view of the ocean on the west side and oil derricks and farmland to the east around Torrance Boulevard and Anza Avenue. Pacific Coast Highway can be seen in the foreground going through both Redondo Beach and Torrance, where there is mostly farmland. (Courtesy City Manager, City of Torrance.)

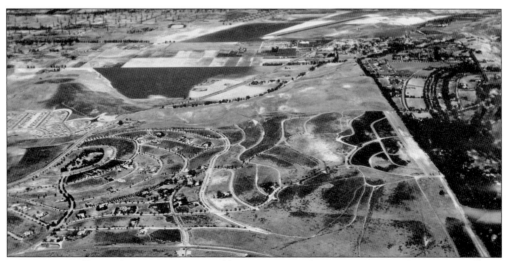

Torrance's Hollywood Riviera is pictured here in 1947. The dark areas in the upper left-hand section of the photograph are part of the seasonal Walteria Lake. (Courtesy City Manager, City of Torrance.)

In 1947, Kenneth and Kay Christofferson moved to Torrance and bought one and three-quarter acres at 3516 Emerald Street to raise chickens and eggs. This 1948 photograph shows Kenneth and friends building the house on what would become K's Poultry and Egg Ranch. They operated their ranch from 1947 through 1960, when residential encroachment made it harder and harder for them to stay in business. (Courtesy Verne Palmer.)

Eight-year-old Tudee Verna Blanche Christofferson, known today as Verne Palmer, is given a ride on her friend's horse near her home and the family's chicken ranch on Emerald Street in west Torrance. (Courtesy Verne Palmer.)

This 1948 photograph shows eight-year-old Verne Palmer standing in the garage of the yet to be completed K's Poultry and Egg Ranch being built by her parents. The family lived in the trailer pictured beside the garage while the house and ranch were being built. (Courtesy Verne Palmer.)

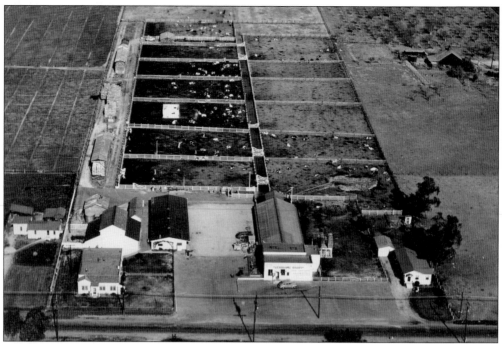

This aerial photograph taken on December 13, 1947, shows Verburg Dairy No. 1, operated by William Verburg. It was located at 2093 West 174th Street, now known as Artesia Boulevard in north Torrance. (Courtesy Joe and Dahlia Verburg.)

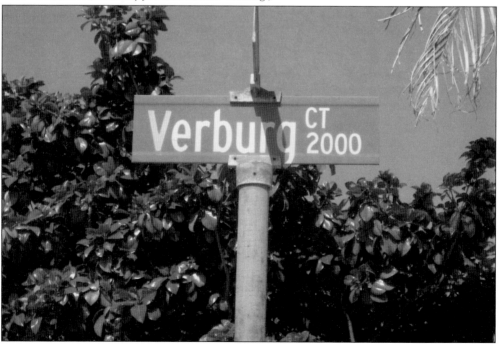

Verburg Court in north Torrance is named after the Verburg family. Verburg Court runs through the back of the original William Verburg Dairy that was located at 2093 Artesia Boulevard when it was still known as 174th Street. (Courtesy author.)

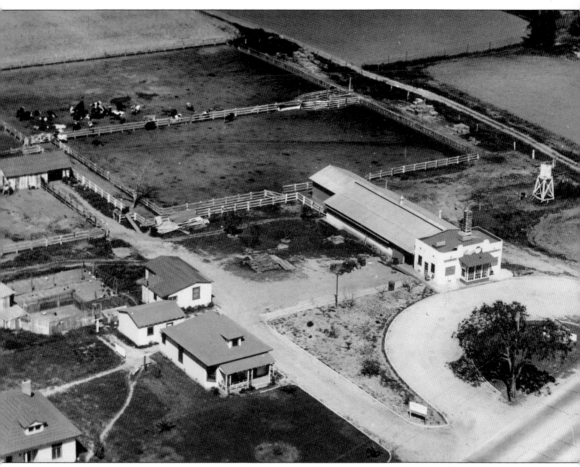

Pictured here is Verburg Dairy No. 2, also photographed on December 13, 1947. It was located on the corner of 182nd Street and Crenshaw Boulevard in north Torrance. The city rezoned the area from agricultural use to single- and multiple-dwelling use in 1963. (Courtesy Joe and Dahlia Verburg.)

The Hudson Dairy is shown in 1947 from its location at 17010 Arlington Avenue (now Van Ness Avenue) in north Torrance. The dairy started with 42 cows, and at its peak of production, it had 65 cows. The dairy barn held 15 cows and used three milking machines. (Courtesy Richard Hudson.)

Pictured here is the calf belonging to Cecil Harold Hudson, son of Cecil L. and Amy Hudson of Hudson Diary. He named the brown Swiss cow Geraldine. (Both courtesy Richard Hudson.)

Not to be outdone by his brother Cecil, Richard Hudson had his own calf, a Holstein he named Snooks. The Hudson Dairy was in operation from 1942 through 1981, when it was operating strictly as a store. (Courtesy Richard Hudson.)

This 1947 photograph from the Hudson Dairy is looking north toward Los Angeles. The dairy shipped milk to Knudsen Creamery until after World War II and had milk routes throughout south Los Angeles. (Courtesy Richard Hudson.)

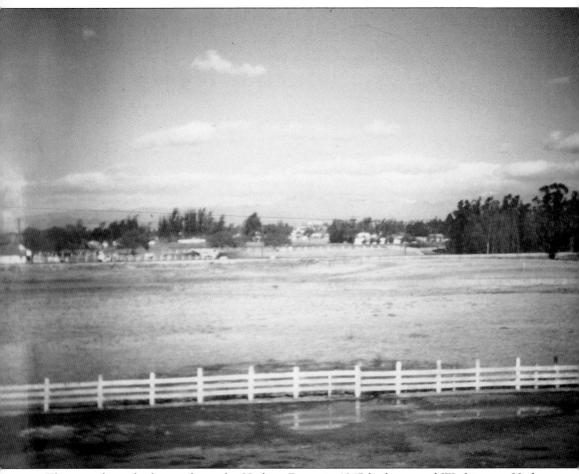

The view from the haystacks at the Hudson Dairy in 1947 looks toward Washington High School in Los Angeles. Hudson was one of several dairies in the same neighborhood in the north Torrance area at the time. Others included the Frietas, Lorraine, Ormonde, and Emerald Glen dairies. (Courtesy Richard Hudson.)

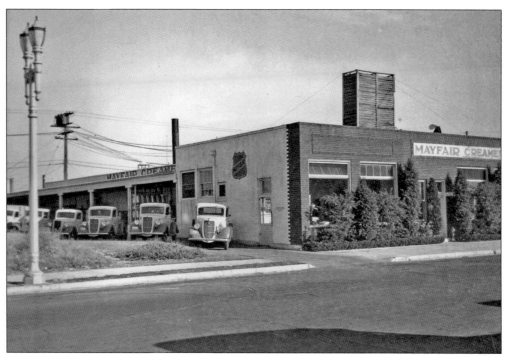

This 1949 view shows the site of the original location of the Mayfair Creamery on Post Avenue in downtown Torrance. Later the creamery moved to Western Avenue. (Courtesy Torrance Historical Society and Museum.)

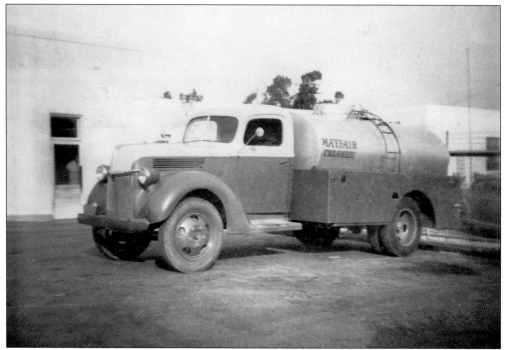

In the mid-1940s, this Mayfair Creamery truck makes a delivery to a local market in downtown Torrance. (Courtesy Torrance Historical Society and Museum.)

The vegetable stand on Figueroa Street, called "The Boys' Market," was open two days a week. During World War II, S.A.I. succeeded not only in supplying the Institute kitchen with vegetables, poultry and eggs, but sold also to hundreds of Defense Workers who passed by on their way to the shipyards.

Gardena's Spanish American Institute was a Methodist school for boys operating from 1913 through 1971. It offered vocational and industrial training to Spanish-speaking boys, including agricultural-related activities such as crop production, livestock production, and operating a farm stand. The institute's 30 acres featured a dairy, farm stock, and fruit orchard, and its products were sold at the Boy's Vegetable Stand to raise funds. (Both courtesy Gardena City Clerk's Office.)

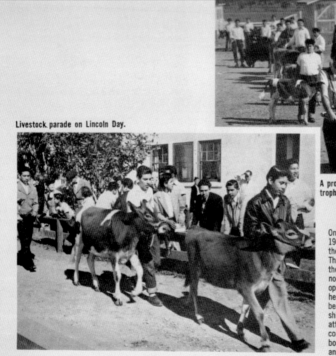

Livestock parade on Lincoln Day.

A proud group of boys return with their trophies to S.A.I.

One of the added features on Lincoln Day 1949 was the display of livestock under the auspices of the newly formed 4-H Club. The boys conceived the idea of showing their animals. They had a parade at the noon hour when all the visitors had an opportunity to watch. Many of the people here were thrilled at the sight of the boys' beautiful purebred Jersey heifers, Berkshire hogs, rabbits and poultry. Another attraction was exhibiting the animals in a contest where each boy received a ribbon for his skill in handling the particular animal he was showing.

Three

AGRICULTURE'S DECLINE
1950s THROUGH 1980s

A truck loaded with hay travels down Crenshaw Boulevard in Torrance in the late 1940s. At that time, Torrance was still home to a large number of acres of barley and other oats used for hay. (Courtesy Torrance Historical Society and Museum.)

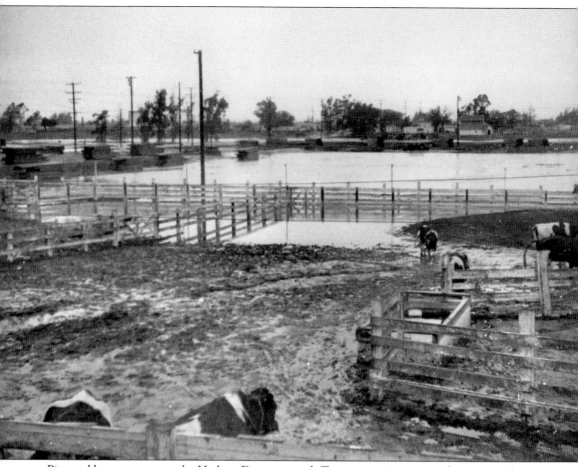

Pictured here are cows at the Hudson Dairy in north Torrance trying to stay above water during the great flood of 1956. Richard Hudson recalls that he started delivering milk in the morning in Manhattan Beach, and by the afternoon, Arlington Avenue (where the dairy was located) was impassable at the Dominguez Creek, so he had to go around it to get back home. (Courtesy Richard Hudson.)

Cecil Hudson opened the Hudson Dairy store at his dairy in the 1950s in north Torrance. Shown here in 1955, the store remained opened until 1981, even after the dairy portion of their operation was forced to close as a result of city ordinances outlawing dairies in the mid-1960s. (Courtesy Richard Hudson.)

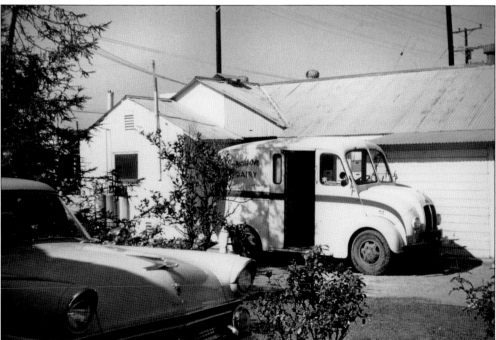

This was the truck used by Cecil L. Hudson and his sons in 1957 to deliver milk to the customers on their dairy milk route. (Courtesy Richard Hudson.)

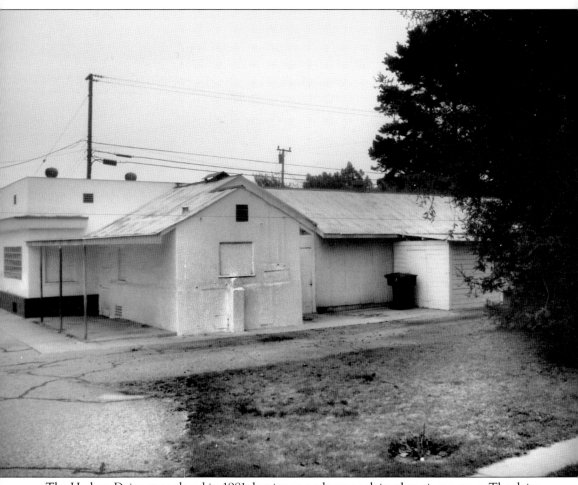

The Hudson Dairy store closed in 1981, but it was no longer a dairy then, just a store. The dairy portion closed in 1965 after the City of Torrance passed laws prohibiting farms from operating in the city. Richard Hudson still lives in the original house, and the barn and former bunkhouse are still standing as well. (Courtesy author.)

This 1956 advertisement from the Torrance Classified City Directory shows there were still a number of dairies located throughout the city, in the north Torrance, City Strip, Meadow Park, and Del Amo areas. (Courtesy Torrance Historical Society and Museum.)

Quinn's Dairy, located on Del Amo Boulevard and operated by Lester and Harriet Quinn, was one of the last six dairies left operating in Torrance in the 1960s. They still had over 200 head of cattle in 1965 when the city eliminated dairy herds. This 1956 advertisement in the Torrance Classified City Directory showcases its popular drive-through feature. (Courtesy Torrance Historical Society and Museum.)

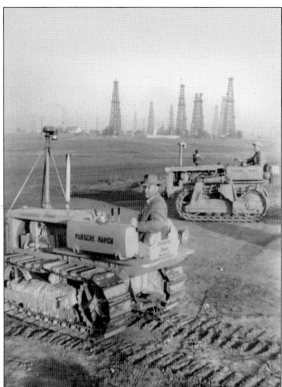

Pursche Ranch foreman Stuart Clark (left) and Bill Smith are pictured in this 1950s photograph at the ranch's grain operation in Gardena. At one time, the Pursche Ranch farmed 1,000 leased acres and owned another 33 acres in Gardena. (Courtesy Roy Pursche.)

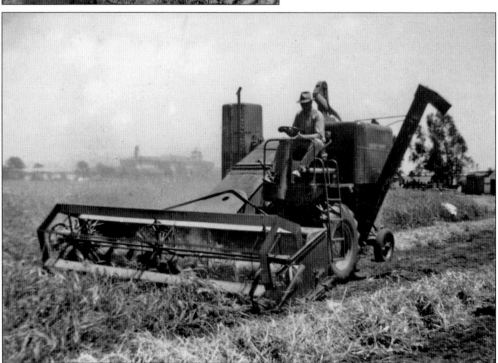

A worker is pictured harvesting barley with a grain combine at the Pursche Ranch in Gardena in the early 1950s. (Courtesy Roy Pursche.)

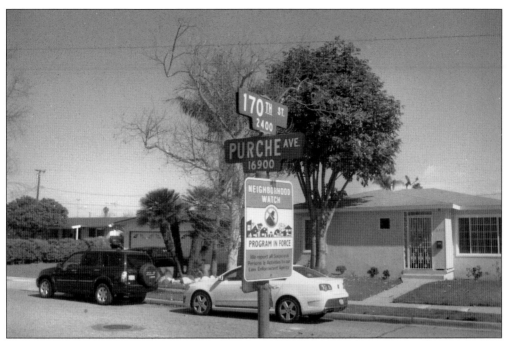

This street was named after the Pursche family. Notice however, that the street is spelled incorrectly. Purche Street originates in Gardena and runs through to north Torrance (where this photograph was taken). According to Roy Pursche, the street originated in Gardena near where the family ranch was, and when they saw the name was wrong, his father said, "You can't fight City Hall," and never bothered to get it corrected. (Courtesy author.)

Code MG 169				VEGETABLE ACREAGE RECORD LOS ANGELES COUNTY AGRICULTURAL COMMISSIONER			For Veg. 50 Acres: Tillable 150				
Inspector C. W. Yerxa											
Farmer & Address _Ishibashi, Mas_											
Farm Location _Pt. Vicente - Palos Verdes Hills - Ranch # 21_											
Land Owner & Address								Date _June 2, 1953_			
DATE	VEG. PLANTED	HARV. MO.	ACRES	DATE	VEG. PLANTED	HARV. MO.	ACRES	DATE	VEG. PLANTED	HARV. MO.	ACRES
-2	Tomatoes	July	8					6-2	celery	Nov	7
	cucumbers	Aug	2						cabbage	"	3
	Strawberries		1½						Peas	Jul	7
10-31	celery	Jan	2						K.Y. beans	May	18
		Feb	9								
		Mar	1								

This Los Angeles County Agricultural Commissioner Crop Card from 1953 shows the list of crops raised by Mas Ishibashi at his Point Vicente/Palos Verdes Hills farm location. The list included celery, strawberries, tomatoes, and cucumbers. (Courtesy Los Angeles Agriculture Commissioner.)

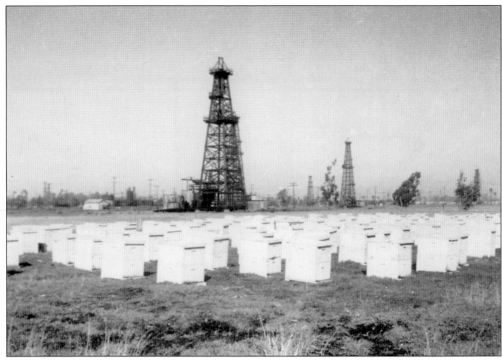

Raymond J. Deurloo, a local Torrance beekeeper, kept bees at Maple Avenue and Carson Street. This is a view looking east from the site in February 1953. (Courtesy Paul R. Comon Collection.)

This 1955 brochure from Bode's Geraniums lists the varieties of geraniums they grew and gives an overview of their flower farm. They were one of several geranium growers located in Dominguez Hills. At that time, they were located on 195th Street, one block east of Avalon, near the present-day Victoria Park Golf Course and residential area surrounding California State University Dominguez Hills. (Courtesy Andrade family.)

90

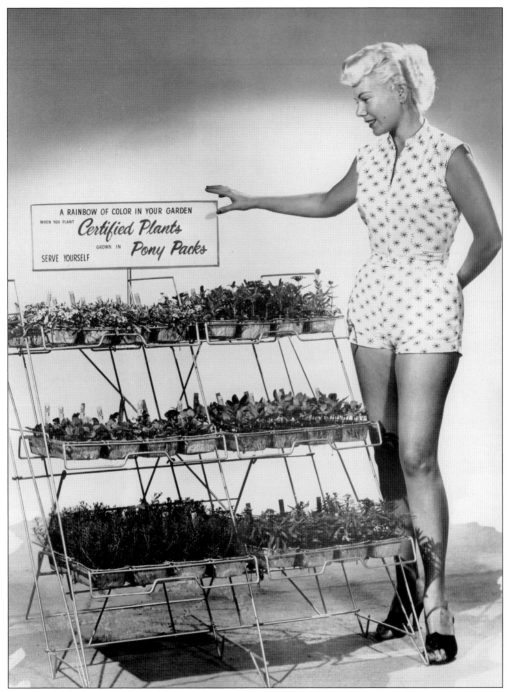

Joelene Mertz poses in this mid-1950s advertisement with the American Plant Growers innovative Pony Pack containers. Partners Bill and Dick Mertz, and Carl Tasche, who started a produce farm in Lomita, eventually began growing bedding plants and relocated to Sepulveda Boulevard on the Carson/Torrance border in the 1950s. They invented the clever containers and revolutionized the plant industry when their plants became the first live plants sold in stores. The packs made purchasing plants convenient and created impulse buying. (Courtesy Joelene Mertz.)

In June 1950, members of the Ihori family pick yellow and white daisies as young Dave Ihori is seen running out in the field of the family's flower farm that was located on 190th Street and Hawthorne Boulevard in Torrance. (Courtesy Sue and Dave Ihori.)

In this 1957 photograph, brothers Steve (front) and Dave (behind) Ihori pose in their parent's Torrance flower field full of sweet Williams and calendula. (Courtesy Sue and Dave Ihori.)

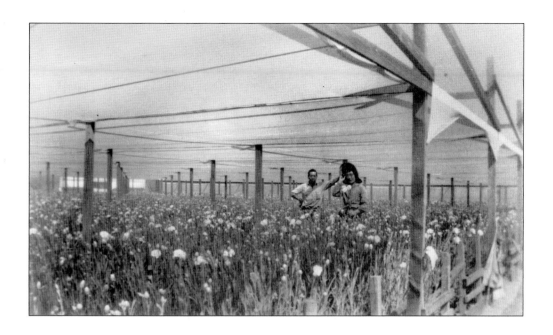

These 1957 photographs show Fred and Sue Ihori standing in Fred's special carnation enclosure. Because he wanted to grow flowers all year long, he created his own type of greenhouse complete with artificial light and artificial heat. This enabled him to sell flowers during the holiday season. As the area kept being sold off to make room for residential development, the Ihoris sold their land in 1960. (Both courtesy Sue and Dave Ihori.)

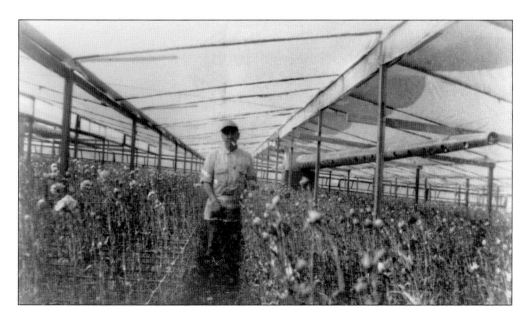

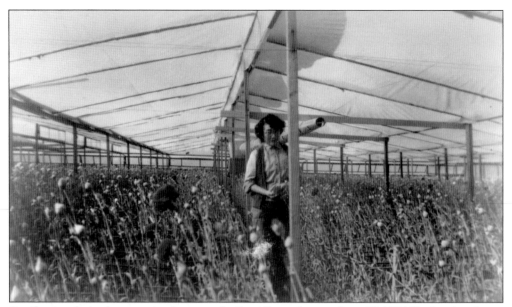

Sue Ihori works in the carnation house at the Ihori flower farm on June 15, 1957. Her brother, James Hatano, was also a well-known flower farmer in the area. He farmed in Torrance and then moved to the Palos Verdes Peninsula, where he still farms today. (Courtesy Sue and Dave Ihori.)

In 1957, seven-year-old Dan Hylands rides a horse at the Good Luck Stables in Gardena. It was one of several horse stables that lined Figueroa Street in Gardena in the 1950s. (Courtesy Daniel Hylands.)

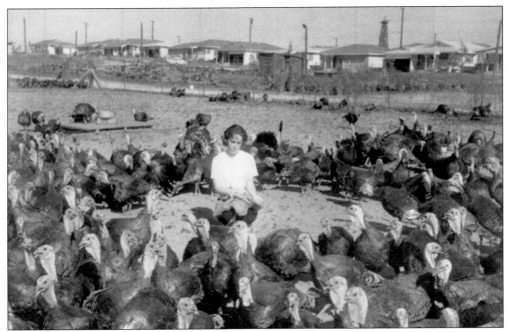

In 1959, Diane Vaccaro sits out in the middle of the Mira Loma Turkey Ranch feeding turkeys as encroaching development surrounds the ranch. The ranch was located on Victor Street and was the last turkey farm in Torrance, finally closing in 1986. (Courtesy City Manager, City of Torrance, from the UCLA Los Angeles Times Archives Collection.)

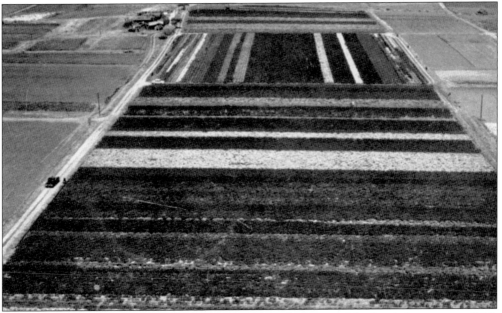

This early-1960s postcard of Avalon Geraniums shows the largest of the farm's four separate fields in Gardena. It was more than one-half mile long and 400 feet wide, and it contained approximately one-quarter million healthy stock plants. It was one of several geranium growers raising flowers for the wholesale market in the Gardena and Dominguez Hills areas from the 1950s through the 1970s. (Courtesy James Osborne.)

This 1961 view along 190th Street in Torrance shows the changing rural landscape with a farm with cows, oil wells, and an industrial area in the background and a newly created construction pit for a multiple housing development in the foreground. (Courtesy Special Collections and Archives, California State University, Dominguez Hills.)

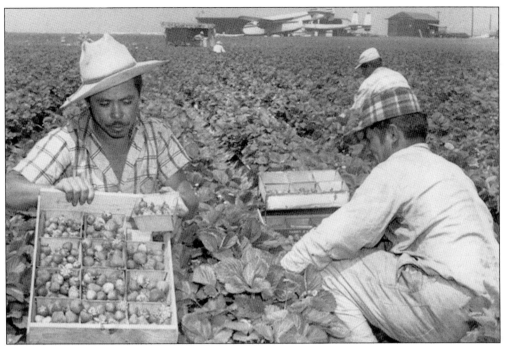

Farm workers are seen here in 1961 picking strawberries in the patch adjacent to Torrance Airport, which has been home to fields of strawberries for the past 50 years. (Courtesy City Manager, City of Torrance, from the UCLA Los Angeles Times Archives Collection.)

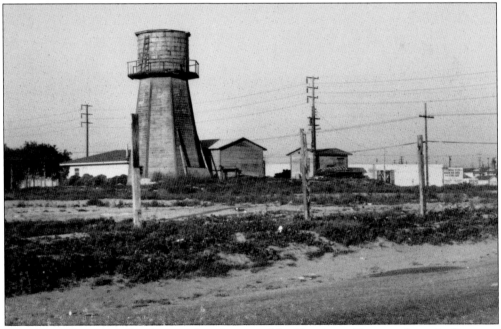

The Abegg Dairy was family owned and operated by Henrietta Abegg and was in Torrance on Hawthorne Boulevard between Lomita and Sepulveda Boulevards on the west side of the street. The dairy's water tower is seen in this mid-1960s photograph. (Courtesy Paul R. Comon Collection.)

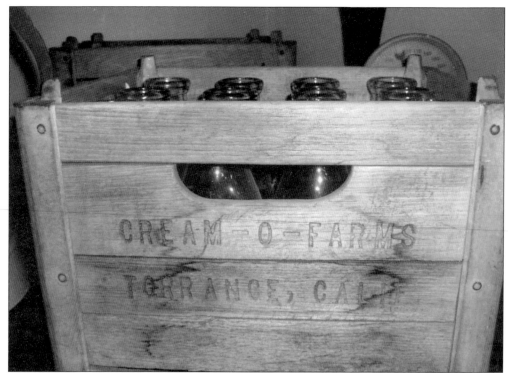

These pieces of dairy memorabilia are all that are left of the dairies that once operated in the city of Torrance. The crate is from the Cream O' Farms Dairy operated by James McCandless and located on Cherry Avenue in north Torrance. The dairy bottle caps are from two of the last Torrance dairies, Hudson's and Quinn's. While there were still a dozen dairies operating in Torrance in 1959, by 1964, the year before farms were outlawed in the city, there were only six left. (Courtesy author.)

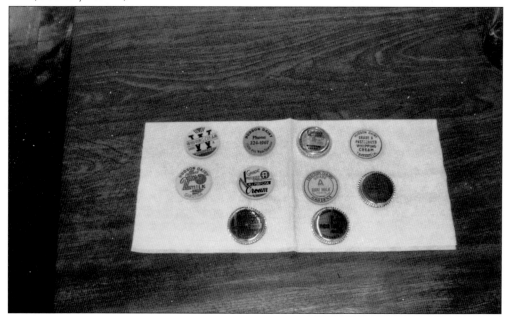

FROM FIELDS TO FACTORIES

This photograph shows the cover of a 1964 Torrance Unified School District booklet given to all third-grade teachers. The booklet covered the history of the city and described how it changed from an agricultural area to a thriving industrial, commercial, and residential suburban community. (Courtesy City Manager, City of Torrance.)

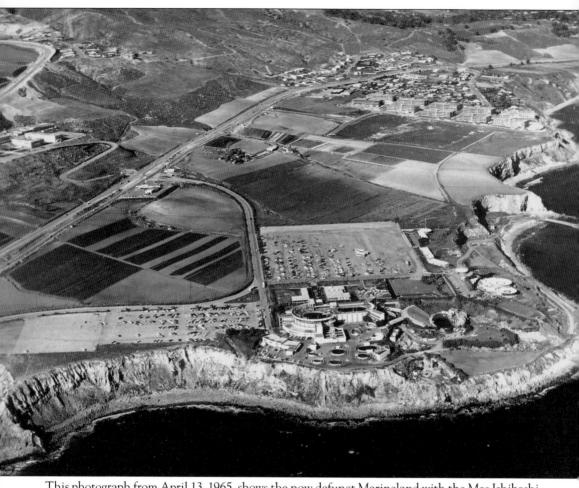

This photograph from April 13, 1965, shows the now defunct Marineland with the Mas Ishibashi farm next to it. Mas Ishibashi farmed 12 leased acres and grew crops including green peas and beans and flowers. (Courtesy Palos Verdes Library Local History Collection.)

This mid-1960s northeast view of Tom T. Ishibashi's Torrance Airport farm is taken from the current location of the Best Buy shopping center on Madison Street and Hawthorne Boulevard. The old oil tank farm on Lomita Boulevard is visible in the background. (Courtesy Paul R. Comon Collection.)

The Meadow Park Dairy water tower is pictured in this 1972 photograph. The view is looking north on the northwest corner of 230th Street and Hawthorne Boulevard. This tower was one of the last remaining pieces of Torrance dairies before it was torn down in the mid-1970s to make room for a retail development. (Courtesy Torrance Historical Society and Museum.)

Beginning in January 1975, a new farming concept began in Torrance as community garden plots at 190th Street and Prairie Avenue (now the site of Columbia Park) were allocated to residents by the City of Torrance through a lottery. There were 52 plots available at the first lottery, and 11 months later, there were 107 garden plots being worked by Torrance residents. (Courtesy Torrance Historical Society and Museum.)

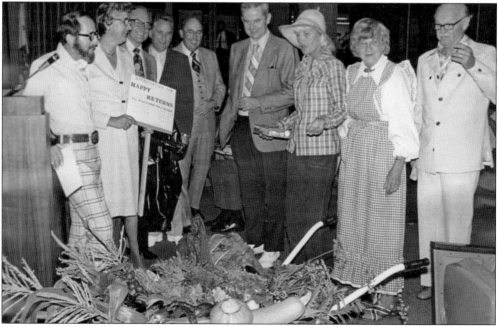

This 1976 photograph features members of the Torrance City Council accepting a bounty of produce grown by amateur Torrance farmers at the Columbia Community Garden. Pictured among the council members are two Torrance mayors. Mayor Jim Armstrong (center) was mayor at that time, and Katy Geissert (second from left) became mayor in the early 1990s. (Courtesy Community Services Department, City of Torrance.)

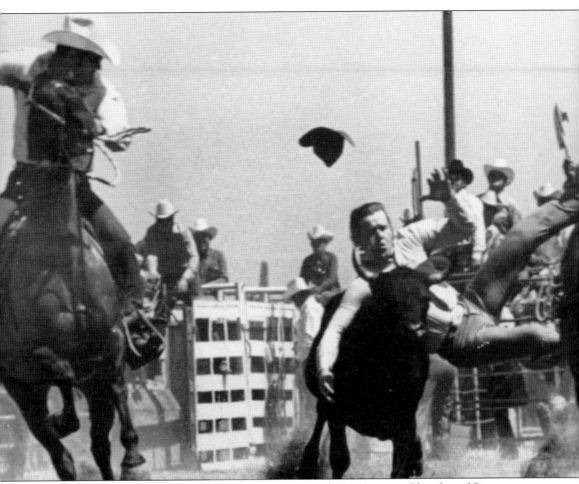

For over 25 years, the Torrance Mounted Posse, along with the Torrance Chamber of Commerce, held an annual Torrance Rodeo. The 1975 rodeo is pictured here. Over the years, the event featured bareback, bull, and steer team roping contests, trick riding, a carnival, clowning, and even a rodeo queen. The last rodeo was held in the early 1980s because there were no longer any suitable sites left to accommodate the rodeo. (Courtesy Torrance Historical Society and Museum.)

Roy Pursche, pictured in this 1979 photograph, was the last farmer to grow large acreages of field crops in the South Bay area. During the 1970s, he grew lima beans and barley on 350 leased acres at Jefferson and Lincoln Boulevards in the Marina del Rey area. The Pursche family first farmed in Gardena and Torrance but relocated as development crowded them out. Today he still farms on 1,500 leased acres of Seal Beach Naval property. (Courtesy Roy Pursche.)

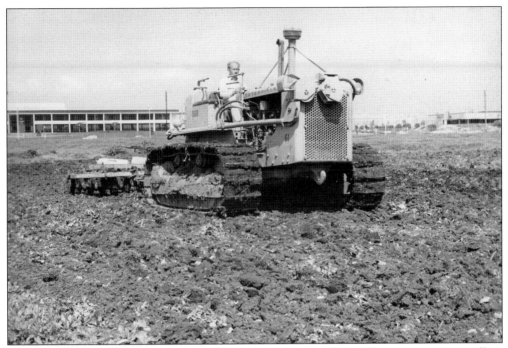

This 1979 photograph shows Roy Pursche operating his D-6 Caterpillar tractor as it is pulling a disc harrow on his acreage in the Marina del Rey area, the site of the present-day Playa Vista development near Ballona Creek. (Courtesy Roy Pursche.)

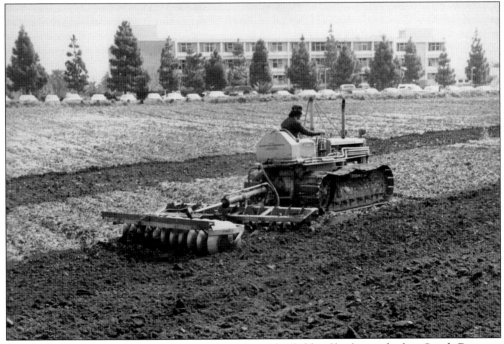

A Pursche Ranch employee moves a tractor across the fields of barley at the last South Bay area farmed by Roy Pursche in this 1979 photograph. Visible in the background behind the fields are the buildings at Loyola Marymount University. (Courtesy Roy Pursche.)

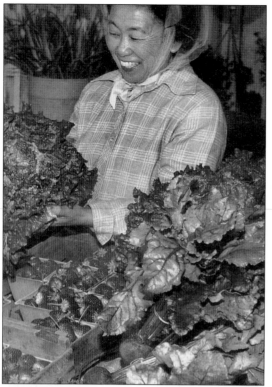

Annie Ishibashi is pictured on the cover of the *Palos Verdes Social Review* in 1977. Annie Ishibashi, wife of Palos Verdes Peninsula farmer James Ishibashi, sold the produce and flowers grown on her family's farm at the "Deliciously Yours" stand on Palos Verdes Drive South from the early 1960s through the early 1990s. (Courtesy Palos Verdes Library Local History Collection.)

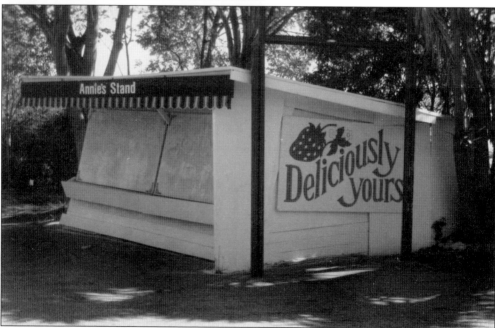

This 2008 photograph shows the now closed produce stand, once known as "Deliciously Yours." The popular stand was run by Annie Ishibashi from the early 1960s through the 1990s and is still standing on the Palos Verdes Peninsula next to Abalone Cove Shoreline Park. After Annie's death, the stand was renamed in her honor. (Courtesy author.)

This 1982 photograph shows several young family members helping out at Tom T. Ishibashi's Torrance Airport Produce Stand. The girls, all cousins, spent their time off from school working at the produce stand. (Courtesy Tom T. Ishibashi.)

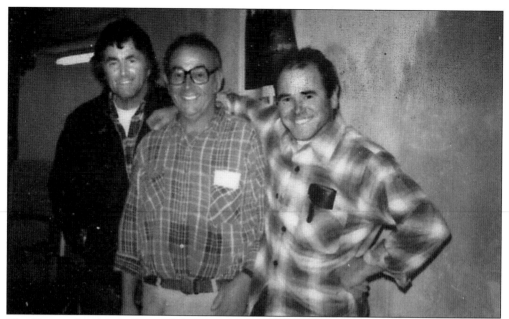

The Vaccaro brothers—Bernard (left), Melvin (center), and Robert (right)—are pictured after a long day of processing turkeys in this early-1980s photograph. Together they operated the Mira Loma Asparagus Ranch until after World War II, when they switched full-time to raising turkeys. The Mira Loma Turkey Ranch processed turkeys in Torrance until 1985. (Courtesy Vaccaro family.)

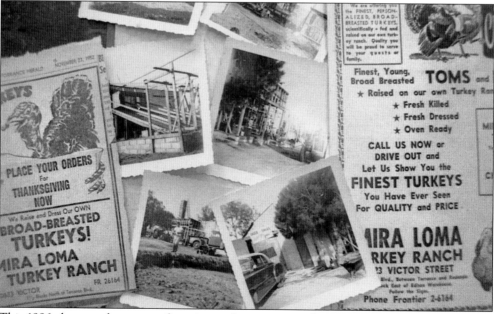

This 1986 photograph montage featuring early newspaper advertisements and snapshots of the Vaccaro family, owners of the Mira Loma Turkey Ranch, appeared in a pre-Thanksgiving feature story in the *Daily Breeze* on November 26, 1986. At its peak in the 1950s, they had expanded to growing 15,000 to 20,000 turkeys a year. They closed in 1986 after 28 consecutive years in business. (Courtesy *Daily Breeze*.)

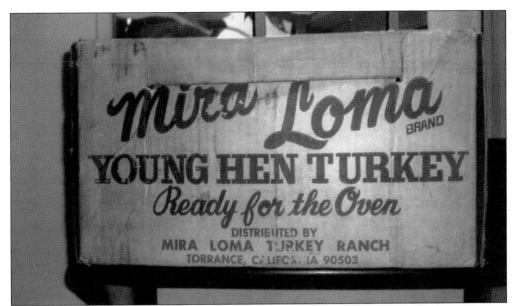

This is an original box left from the last turkey ranch in Torrance, the Mira Loma Turkey Ranch. In 1918, David Vaccaro began raising vegetables on 20 acres in Torrance, mostly asparagus. However, it required another cash crop, so he decided to raise turkeys to supplement his income. After World War II, the Vaccaros decided to focus on turkey ranching full-time. In 1961, when West High and Victor Elementary Schools were built, they were forced to stop raising turkeys and switched to just processing turkeys. Some of their original ranch became Victor Elementary School. (Courtesy author.)

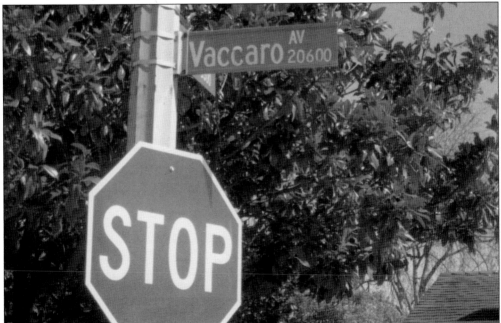

The Vaccaro family farmed in west Torrance from the 1930s through the 1980s. The street was named for them at the location of their original turkey farm, the Mira Loma Turkey Ranch, near Emerald and Victor Streets. (Courtesy author.)

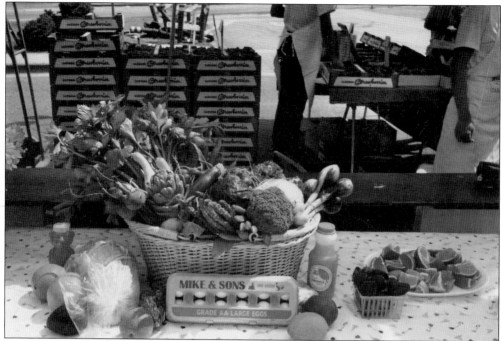

The Torrance Certified Farmers' Market officially opened Tuesday, June 4, 1985, and from the beginning, enthusiastic crowds have come to the market to purchase fresh fruits and vegetables. In the 1970s, once family farms were gone from most urban areas, the State of California created farmers' markets to allow consumers to buy farm-fresh produce directly from farmers, eliminating the packing, labeling, shipping, and wholesale costs and creating a much-needed market for small farmers. (Both courtesy Mary Lou Weiss, Torrance Certified Farmers' Market.)

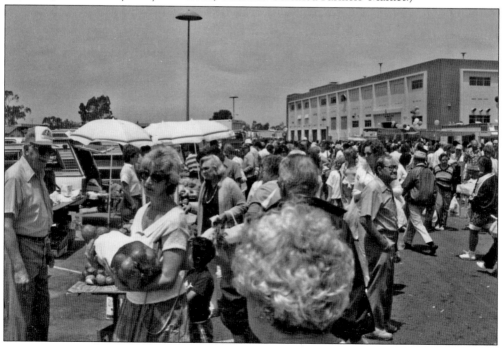

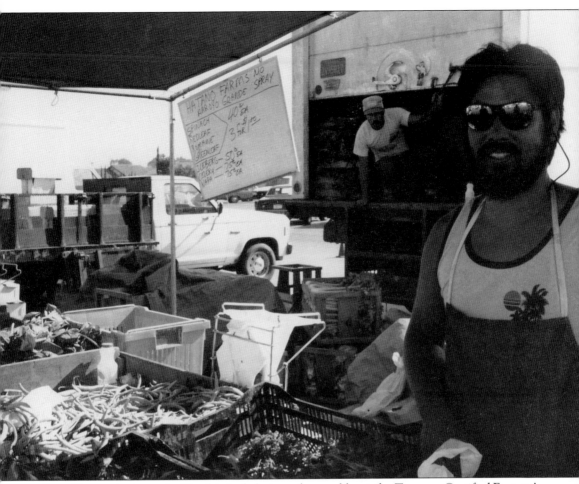

Doug Hatano is pictured selling his fresh fruits and vegetables at the Torrance Certified Farmers' Market in this 1985 photograph. Hatano grew up in a farming family on the Palos Verdes Peninsula but moved to Arroyo Grande to farm from 1984 to 1991. His father, James Hatano, still farms on the peninsula. (Courtesy Mary Lou Weiss, Torrance Certified Farmers' Market.)

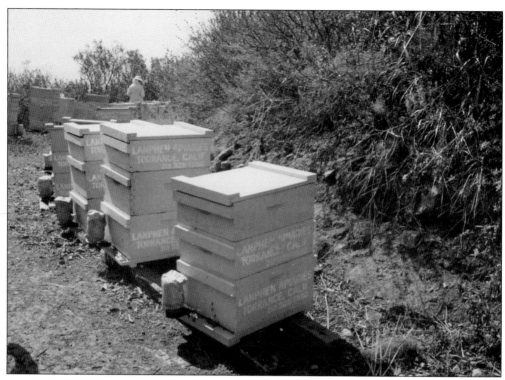

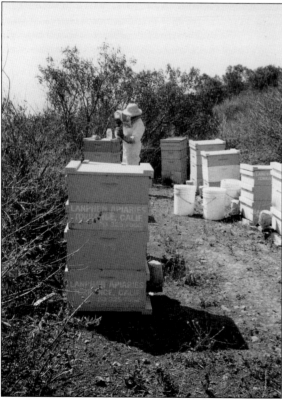

Geurt Lanphen is pictured in these 1980s photographs, collecting bees for honey in his bee boxes on the Palos Verdes Peninsula. Geurt and Gertrude Lanphen were Torrance beekeepers who sold their honey and volunteered at the Torrance Certified Farmers' Market. (Both courtesy Mary Lou Weiss, Torrance Certified Farmers' Market.)

Visitors from the Torrance Historical Society and Museum tour the Weston Ranch house in 1987, shortly before it was moved from its original location to be temporarily housed at Wilson Park in Torrance. It eventually was relocated and restored and is now believed to be a private residence in Pasadena. (Courtesy Torrance Historical Society and Museum.)

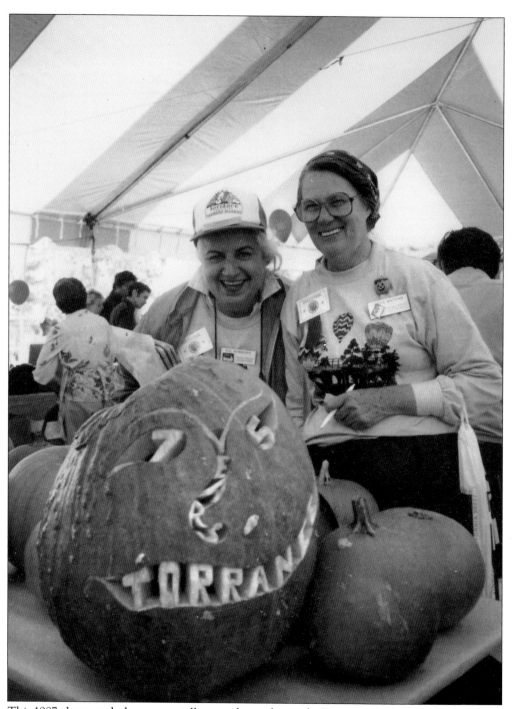

This 1987 photograph shows a specially carved pumpkin at the Torrance Certified Farmers' Market to celebrate the 75th anniversary of Torrance, which was founded by Jared Sydney Torrance in 1912. (Courtesy Mary Lou Weiss, Torrance Certified Farmers' Market.)

Four

URBAN AGRICULTURE TODAY
1990s THROUGH PRESENT

Customers are seen lining up to buy fresh from the farm produce at the Tom T. Ishibashi Produce Stand at Torrance Airport in this August 1990 photograph. During strawberry season (spring and early summer), people line up daily until they sell out. They are also busy around Halloween and Thanksgiving with pumpkins and corn. (Courtesy *Daily Breeze*.)

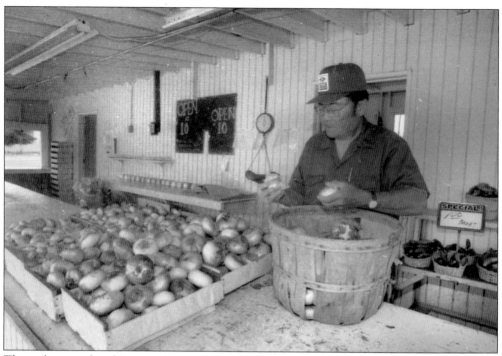

These photographs of Tom and Maya Ishibashi appeared in a *Daily Breeze* article from August 22, 1990, focusing on disappearing roadside stands. Maya's husband, Tom, farms at Torrance Airport and sells his fresh produce at the Tom T. Ishibashi Produce Stand at 24955 Crenshaw Boulevard, right next to the airport. They moved the stand from Pacific Coast Highway in the late 1980s when developers took over their land. It is best known for strawberries in the spring and early summer. (Both courtesy *Daily Breeze*.)

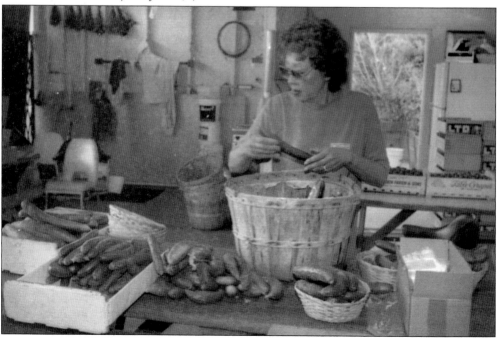

James Ishibashi is pictured in 1993 at his farm on Paseo del Mar in Portuguese Bend on the Palos Verdes Peninsula. His father, Tomizo Ishibashi, and uncle, Kumekichi Ishibashi, were the first to farm on the peninsula, and his cousin Mas Ishibashi operated the first produce stand on the peninsula. James Ishibashi retired in 1998 when the eight and a half acres where he grew strawberries, vegetables, and flowers became the Ocean Trails Golf Club, now Trump National Golf Course. James died in 2002. (Courtesy *Daily Breeze*.)

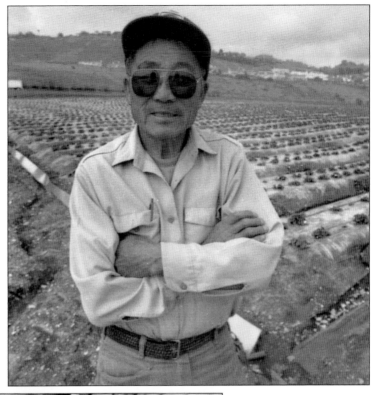

In this 1995 photograph, Bill Mertz is pictured among the poinsettias at his family's company, American Plant Growers. Established in 1944, its original product line included celery, Anaheim chili peppers, tomatoes, and bell peppers. It grew to become one of the largest bedding plant providers in the West. It was sold to Color Spot in the late 1990s, the largest wholesale nursery of bedding plants in the United States. While operating as American Plant Growers, Mertz and his partners invented and patented the Color Pack and Pony Pack containers. (Courtesy Bill Mertz.)

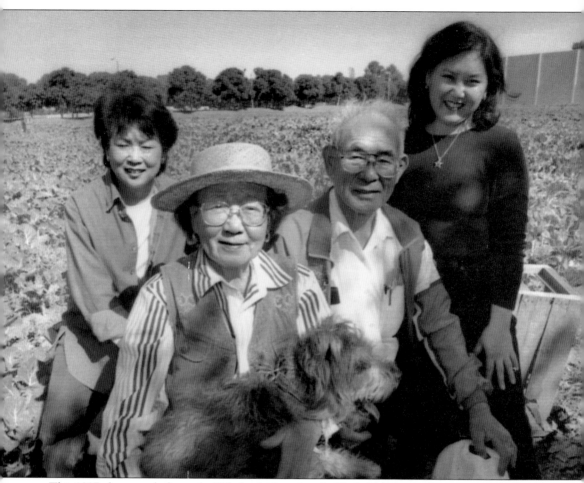

This 1997 photograph shows the Takahashi farm family: Kachi Takahashi, her parents, Frank and Mary Takahashi, and Kachi's daughter Naomi Sweredoski. They farmed in Carson on a 35-acre farm known as Top Veg. They leased from the Watson Land Company, and at their peak in the mid-1960s, they had 200 acres. Frank and Mary started the Carson farm in 1964. It was located off Wilmington Avenue, bisected by 220th Street and bordered to the south by the San Diego Freeway. They raised lettuce, strawberries, spinach, basil, arugula, leeks, and butter beans. Top Veg was a familiar face at the Torrance Certified Farmers' Market since they sold most of their produce at local farmers' markets. They were forced to close when the land was redeveloped. Today Naomi and her husband, John Sweredoski, farm in Long Beach. (Courtesy *Daily Breeze*.)

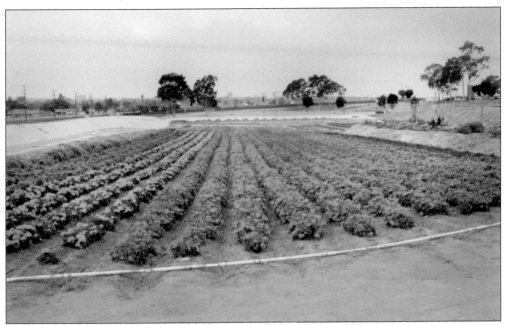

Grand View Geranium Gardens is the last flower grower left in Dominguez Hills. Owned and operated by the Andrade family since 1954, the business was started by Tony and Mary Lou Andrade on just five acres. By the late 1960s, Grand View was growing over 500 geranium varieties on 85 acres. Many flower growers located in Dominguez Hills because its elevation offered frost protection to delicate flowers and it was close to LAX to facilitate transportation. Today the farm sits on 39 acres atop a hill alongside California State University Dominguez Hills. Grand View is a wholesale grower of over 100 different varieties of geraniums. Its products are sold throughout California, Arizona, Nevada, and Utah to major retailers, including Home Depot, Target, Wal-Mart, and Armstrong Garden Centers. (Both courtesy author.)

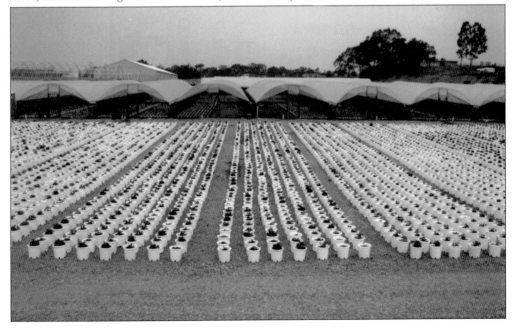

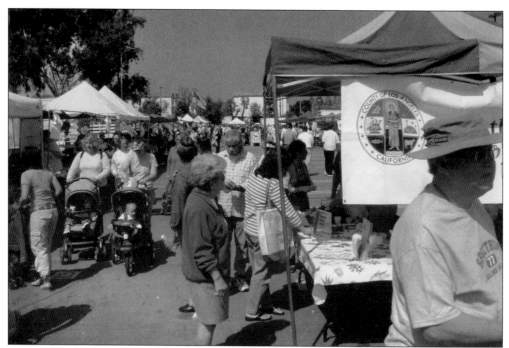

The Tuesday Torrance Certified Farmers' Market began in June 1985, and the Saturday Torrance Certified Farmers' Market opened in March 1992. The Torrance Certified Farmers' Market is the third largest market in Los Angeles County. After traditional farms were gone, renewed interest in "raw" crops instead of highly processed food and artificial ingredients led to the growth of certified farmers' markets. Los Angeles County's first certified farmers' market opened in 1979 in Gardena and continues today as one of over 90 operating in the county, representing about 25 percent of all farmers' markets in California. (Both courtesy author.)

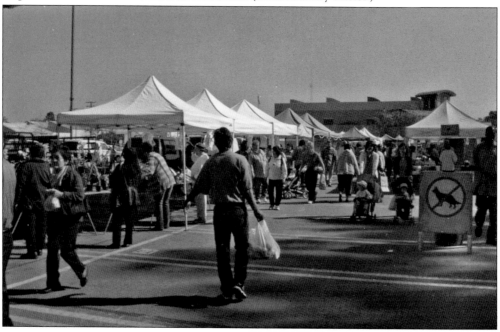

These 2008 photographs show the large bronze plaque that marks the site of the original Kumekichi Ishibashi Ranch, the first Japanese American farm on the Palos Verdes Peninsula. In 1906, Kumekichi leased his first farm property on the peninsula and farmed by the dry farming method, growing beans, cucumbers, peas, and tomatoes. On August 27, 2005, this bronze plaque was dedicated at Founders' Park in Rancho Palos Verdes. Founders' Park is a five-acre bluff-top park of grass, picnic tables, and ocean trails constructed behind the Trump National Golf Course clubhouse. The plaque honors the many Japanese farmers who worked the fields of the Palos Verdes Peninsula and features engraved images of early Palos Verdes farms along with a narrative saluting the Ishibashi family. (Both courtesy author.)

This 2008 photograph shows James Hatano's farm, the last farm remaining on the Palos Verdes Peninsula. Hatano still grows cut flowers just as he has since 1952. He sells his flowers at the wholesale flower market in downtown Los Angeles. He also grows edible cactus (mopales), which now makes up about half of the products he grows. Hatano farms on approximately eight acres on upper Point Vicente across from the defunct Marineland theme park and on lower Point Vicente near the landmark lighthouse. (Courtesy author.)

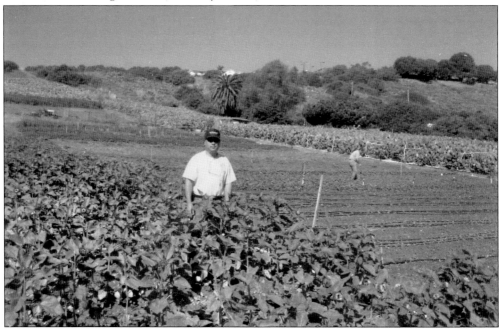

In February 2008, Doug Hatano stands in the sunflower field at his father's farm on the Palos Verdes Peninsula. His father, James Hatano, is now 80 years old but still works every day, with help from his workers and, when needed, Doug. In addition to sunflowers, James Hatano grows Iceland poppies, delphinium, tuberose, and baby's breath. (Courtesy author.)

With the decline in local farms, community gardens have increased because people now recognize the need for regional food sources within urban areas. This is clearly evident in Torrance. The Columbia Park Community Gardens (pictured here) have been open since January 1975. Started with just 50 garden plots, today there are 125, and there are always people on the waiting list. The community gardens were so successful that a second location was opened at Lago Seco Park; it also has 125 plots. When Lago Seco Park was renovated in 2005, the community gardens also got an upgrade, including a new demonstration area, handicapped-accessible garden spaces, new lighting, an information kiosk, and hose connections at every plot. (Both courtesy author.)

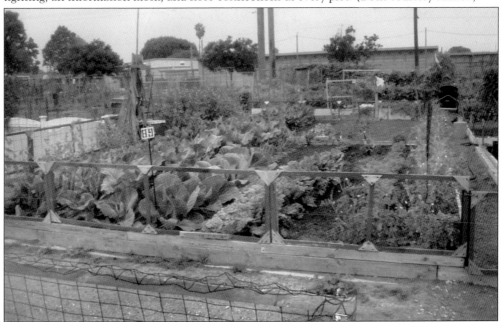

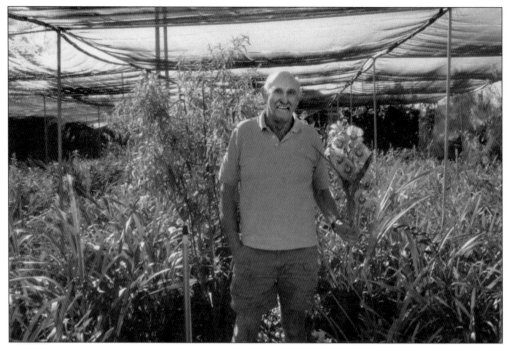

Jim Weiss is a modern, urban farmer. His farm, the Orchid Garden, is located in north Torrance and is typical of farms in the city. Weiss grows his orchids, flowers, and potted plants on one and a quarter acres of land that he leases from Southern California Edison, literally under the power lines. Edison property has a lot of restrictive regulations, but it is the only open space left for city farmers. Jim Weiss sells nursery products at five South Bay area farmers' markets, including the Torrance Certified Farmers' Market. (Both courtesy author.)

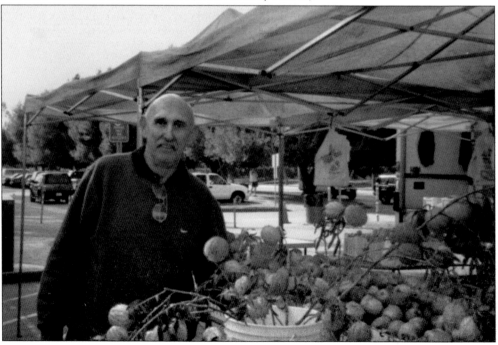

This wholesale nursery in Redondo Beach along 190th Street, called Landscape Garden Nursery, is typical of the kinds of growers left in Los Angeles County and the South Bay. Edison leases about two-thirds of its leased land to nurseries. According to the Los Angeles County Agriculture Commissioner's Office, in 2005, there were approximately 243 urban agriculture businesses operating in the metropolitan L.A. basin, 110 farms, and 133 nurseries. (Courtesy author.)

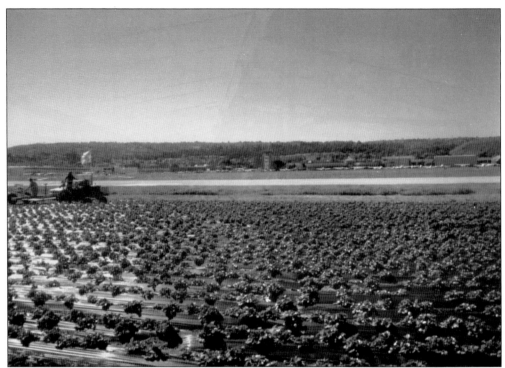

Tom T. Ishibashi's farm at Torrance Airport is the last "real" farm left in the city of Torrance. Ishibashi first leased 150 acres at Torrance Airport in 1960. Today he has approximately 50 acres, and 20 of them are between airport runways. Ishibashi grows strawberries, string beans, zucchini, cucumber, beets, carrots, corn, tomatoes, sweet peas, tomatoes, cosmos, stocks, poppies, and pumpkins. The farm's produce is sold at the stand on Crenshaw Boulevard next to the farm. (Both courtesy author.)

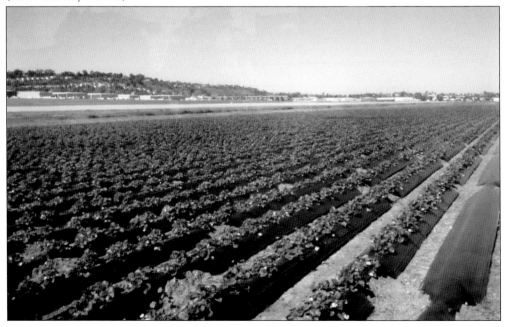

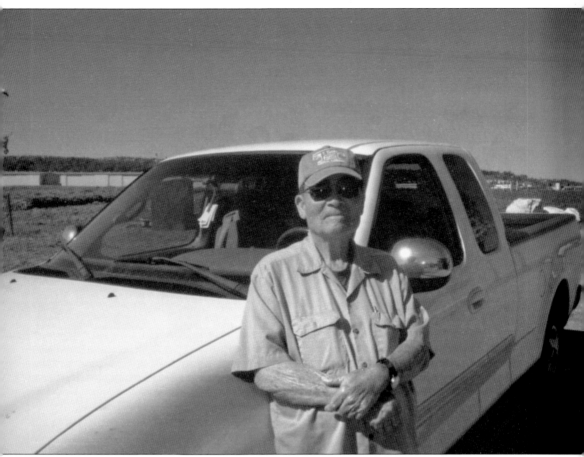

Tom T. Ishibashi, the last traditional farmer left in Torrance, is pictured here in February 2008. Ishibashi has been farming in Torrance since the late 1950s. His family has been farming in the South Bay area since the early 1900s, and at age 80, he has no plans to retire. (Courtesy author.)

BIBLIOGRAPHY

Aldershof, Gertrude, et al. *History of Torrance: A Teacher's Resource Guide*. Torrance, CA: Torrance Board of Education, 1964.

Coil, Vernon W. *History of Torrance*. Torrance, CA: City of Torrance, 1967.

Rische, Thomas. *The History of Torrance Schools: 1890–2000*. Torrance, CA: Torrance Unified School District, 2002.

Shanahan, Dennis F., and Charles Elliott Jr. *Historic Torrance: A Pictorial History of Torrance, California*. Redondo Beach, CA: Legends Press, 1984.

Whitman, Louise Bodger. *The House of Bodger*. Glendale, CA: Bodger Seeds, 1981.

ACROSS AMERICA, PEOPLE ARE DISCOVERING
SOMETHING WONDERFUL. THEIR HERITAGE.

Arcadia Publishing is the leading local history publisher in the United States. With more than 4,000 titles in print and hundreds of new titles released every year, Arcadia has extensive specialized experience chronicling the history of communities and celebrating America's hidden stories, bringing to life the people, places, and events from the past. To discover the history of other communities across the nation, please visit:

www.arcadiapublishing.com

Customized search tools allow you to find regional history books about the town where you grew up, the cities where your friends and family live, the town where your parents met, or even that retirement spot you've been dreaming about.